D0791747

The Designer's Guide to SYMBOL & ICON FONTS Online

Edited by
Kathleen Ziegler
Nick Greco

Dimensional Illustrators, Inc.

HBI
an imprint of HarperCollins International

First Published 2001 by:
Dimensional Illustrators, Inc.
For HBI, an imprint of
HarperCollins Publishers
10 East 53rd Street
New York, NY 10022-5299 USA

ISBN: 0-06-093777-7

Distributed to the trade and art markets in the US by:
North Light Books, an imprint of F & W Publications, Inc.
1507 Dana Avenue
Cincinnati, OH 45207
800.289.0963 Telephone

Distributed throughout the rest of the world by:
HarperCollins International
10 East 53rd Street
New York, NY 10022-5299 USA
212.207.7654 Fax

Address Direct Mail Sales to:
Dimensional Illustrators, Inc.
362 Second Street Pike / # 112
Southampton, Pennsylvania 18966 USA
215.953.1415 Telephone
215.953.1697 Fax
Email: dimension@3dimillus.com
Website: http://www.3dimillus.com

Copyright © 2001 by Dimensional Illustrators, Inc. and HBI, an imprint of HarperCollins Publishers
Printed in Hong Kong

All rights reserved. No part of this book may be used or reproduced in any form or by an electronic or mechanical means, including information storage and retrieval systems, without written permission of the copyright owners, except by a reviewer who may quote brief passages in a review. The captions, information and artwork in this book have been supplied by the designers and illustrators. All works have been reproduced on the condition they are reproduced with the knowledge and prior consent of the designers, clients, companies and/or other interested parties. No responsibility is accepted by Dimensional Illustrators, Inc., HBI an imprint of HarperCollins Publishers or printer for any infringement of copyright or otherwise arising from the contents of this publication. Every effort has been made to ensure captions accurately comply with information supplied. The publisher cannot under any circumstances accept responsibility for errors or omissions. All products or name brands used in this book are trademarks registered trademarks or tradenames of their respective holders.
No artwork or part of any artwork may be reproduced without written permission by the authors, artists, designers or owners. No typeface or part of any typefont may be reproduced without written permission by the authors, artists, designers or owners.

From NEUROMANCER by William Gibson, copyright ©1984 by William Gibson. Used by permission of Viking Penguin, a division of Penguin Putnam Inc. Used by permission of William Gibson and Martha Millard Literary Agency.

Type samples and typefont artwork:
Copyright © 2001 [+ISM]
Copyright © 2001 Behaviour Group
Copyright ©1993–2001 Joshua Distler and Shift. All rights reserved. Shift is a registered trademark of Shift.
Copyright © 2001 The Elsner+Flake Digital Library
Copyright © 2001 fontBoy, a trademark of Aufuldish & Warinner.
Copyright © 1993–2001 GarageFonts
Copyright © 2001 LunchBox Studios
Copyright © 2001 Manfred Klein
Copyright © 2001 Nekton Design
Copyright © 2001 P22 Type Foundry
Copyright © 2001 Fabrizio Schiavi
Copyright © 2001 Type[A] Digital Foundry

Credits

Creative Director / Associate Editor
Kathleen Ziegler Dimensional Illustrators, Inc.

Executive Editor
Nick Greco Dimensional Illustrators, Inc.

Book Design and Typography
Deborah Davis Deborah Davis Design

Initial Book Design
Steve Bridges Bridges Design

Cover Design and Typography
Deborah Davis Deborah Davis Design

Cover Artwork
Thomas Schostok ©2001

Page 6
Art **James Grieshaber, Lewis Tsalis**
Fonts **Atomica, Buzzcog[A], HubaHuba**

Page 14–15
Art **Richard Kegler, Cristina Torre**
Fonts **Michelangelo Extras, Rodin Extras, Hieroglyphs**

Page 104–105
Art **Felicia Anggoro, Bob Aufuldish, Chris Weiner**
Fonts **Astound Dings, Larvae, Witches Brood**

Table of Contents

INTRODUCTION

Primarily descendants of early Hieroglyphic pictograph scripts, symbol fonts have evolved into a unique hybrid fontlogy. Designers have created a fresh visual language, devoid of letterforms, that is not spoken, but interpreted. The Designer's Guide To Symbol & Icon Fonts Online showcases the finest collection of graphic symbols, icons, elements, extras and cool dingbats. This publication features 15 prominent commercial and independent online foundries and designers including: +ISM, Behaviour Group, Elsner-Flake Digital Library, fontBoy, FSI FontShop International, GarageFonts, Manfred Klein, Lunchbox Studios, MyFonts.com, Nekton Design, P22 Type Foundry, Inc., Fabrizio Schiavi, Shift, [T26] Type Foundry and Type[A] Digital Foundry.

This premiere guidebook presents more than 60 dynamic symbol font families from aboriginal to abstract, cosmic to geometric, pictorial to political and retro to techno. The Designer's Guide To Symbol & Icon Fonts Online is divided alphabetically by symbol font name and includes descriptive text, font families, number of elements and two inspirational illustrations that feature each typefont in a graphic design. Website addresses are provided for easy access to purchase the typefont online. On page 104, character specimen showings are presented in black type and drop out white showing the key charts. Our editors have canvassed the hottest foundries and designers worldwide from Australia, England, Germany, Italy, Japan, Norway, Thailand and the United States to feature the coolest symbol and icon fonts online. The Designer's Guide To Symbol & Icon Fonts Online explores what the new digital dialects bring to the printed page.

—Editors, Kathleen Ziegler and Nick Greco

How To Use This Book

The Designer's Guide To Symbol & Icon Fonts Online is divided alphabetically by symbol font name and includes descriptive text, font families, number of elements and two inspirational illustrations that feature each typefont in a graphic design. In addition, website addresses are provided for reference.

Reference Symbol: Located in the upper left hand corner of each page, the symbol helps to identify the font within each category.

Font Families: Details the specific font families included in the font.

Elements: Indicate the number of elements in the symbol font.

Style: Categorizes the design of the typeface. A complete list of *Fonts by Style* are listed in the back of the book on page 170.

Showings Page: Indicates the exact page of the symbol font showings. Listing includes partial character sets and font families. Type is shown in black and white.

Application: Shows typographical designs using the font.

Website Address: The essential key to finding the digital typefont for purchase online.

Font Designer: Indicates the typefont designer and country location.

Font Description: Text describes the font features and characteristics as supplied by the designer or foundry.

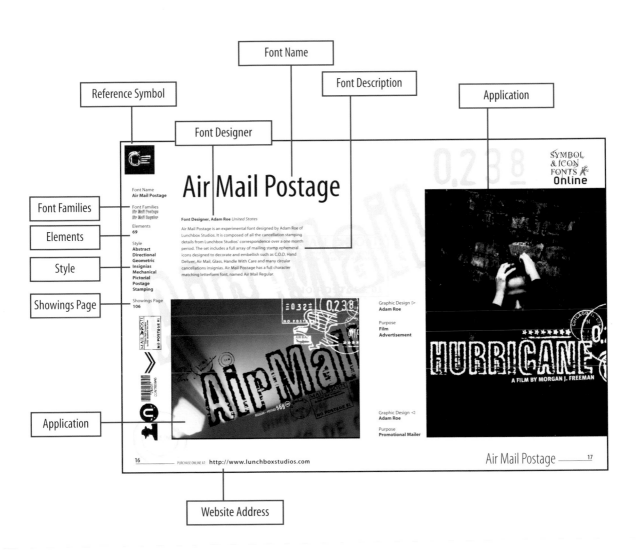

Reference Symbol

Font Name

Font Description

Application

Font Designer

Air Mail Postage

Font Name
Air Mail Postage

Font Families
Air Mail Postage
Air Mail Regular

Font Families

Elements
69

Elements

Style
Abstract
Directional
Geometric
Insignias
Mechanical
Pictorial
Postage
Stamping

Style

Showings Page
106

Showings Page

Font Designer, Adam Roe *United States*

Air Mail Postage is an experimental font designed by Adam Roe of Lunchbox Studios. It is composed of all the cancellation stamping details from Lunchbox Studios' correspondence over a one month period. The set includes a full array of mailing stamp ephemeral icons designed to decorate and embellish such as C.O.D. Hand Deliver, Air Mail, Glass, Handle With Care and many circular cancellations insignias. Air Mail Postage has a full character matching letterform font, named Air Mail Regular.

Graphic Design ▷
Adam Roe

Purpose
Film
Advertisement

Graphic Design ◁
Adam Roe

Purpose
Promotional Mailer

Application

PURCHASE ONLINE AT: **http://www.lunchboxstudios.com**

Air Mail Postage ——

Website Address

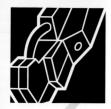

Digital Foundries and Type Designers

+ISM—http://www.plusism.com

+ISM, founded by Matius Gerardo Grieck and Tsuyoshi Nakazako, is an inter-disciplinary conceptual artists collective which was formed in Tokyo, now based in London. Originating from Installation Art, the core idea is the cross-fertilization of various media and collaborations in an attempt to subvert extrinsic content to its prevalent purpose. The +ISM font collection, existing only in digital format at www.plusism.com, has a navigational system divided into four sections that introduces each typefont in detail.

1. Prototype...............(displaying font characteristics)
2. Concept..................(description and background)
3. Character X(set examples/families)
4. Interpretation(image presentation of font)

Behaviour Group—http://www.behaviourgroup.com

Graphic Behaviour is a group of designers founded in 1996 by Anuthin Wongsunkakon and Nirut Krusuansombat. The group started designing following the post Macintosh graphic design stream. In 1998 the studio gradually evolved into the full production of digital typographic materials and related objects. Graphic Behaviour designs text, display and picture faces with a post-modern flare to serve in-house production and custom made typefaces. Graphic Behaviour strives to achieve a higher level of design than most other commercial houses; searching for communication through the behaviour of graphics.

The Elsner+Flake Digital Library—http://www.ef-fonts.de

In 1985 Veronika Elsner and Günther Flake founded their company Elsner+Flake Design Studios after ten years of freelance experience in the area of type design, typography and digitizing of fonts and logos. The general aim of the company is to create a continuously growing library of digital fonts. In the year 2000 this library contained more than 2,000 fonts in PostScript for Apple Macintosh and IBM PC & compatibles, PostScript as well as TrueType. In fact, Elsner+Flake is one of the largest, yet lesser-known digital foundries in Europe. The fonts, which are mainly based on the IKARUS-technology, are either manufactured at the Elsner+Flake studios or licensed from original sources considering the requirements of good legibility and readability while maintaining the beauty of the original drawings. Elsner+Flake typefaces are designed to meet the demanding requirements of the European design community. Complete kerning tables guarantee that the text and display typefaces have a fine appearance and excellent legibility. Accents on

caps and lowercase letters are individually designed. All italics are true italics. Many typefaces are completed with Small Caps and Old Style numbers. Every character is digitized with great accuracy. This is evident if the types are sized very large—smooth curves and fine details are held. The range of fonts reaches from classic typefaces from the libraries of ATF, Bauer, ITC, Letraset, Linotype-Hell, to the wild Beasty Bodies of the late nineties. The Elsner+Flake Digital Library is constantly growing. Not only are new Latin designs added in Central European and Turkish character layout to meet the demand of East European Communities, there is also a wide range of Hebrew and non-Latin fonts in the Elsner+Flake Digital Library. Elsner+Flake cooperates worldwide with more than 30 business partners.

fontBoy—http://www.fontboy.com

FontBoy.com was launched in the summer of 1995 to manufacture and distribute fonts designed by Bob Aufuldish and Kathy Warinner of the design office, Aufuldish & Warinner. The foundry maintains a website at www.fontboy.com with a secure store front—fonts are available in Mac and Windows formats. The foundry has released fonts ranging from the quirky and handmade to the geometrically precise. The current direction of their work incorporates more classic elements. Aufuldish & Warinner try to focus on what interests them rather than trying to chase trends. They prefer the wide-open early 20th century modernism, rather than the formulaic high modernism of the international style.

FSI FontShop International—http://www.fontfont.com

FSI, FontShop International, founded in 1990, is a renowned type foundry based in Berlin, Germany, with an office in San Francisco. The FontFont Library has the world's largest collection of original, contemporary typefaces. This unique Library contains a variety of outstanding type designs. The spectrum of styles includes tasteful, high-quality text faces, eye-catching display fonts, amusing fun fonts and terrifying destructive fonts that reflect current moods and set typographic trends. The Library features the work of the foremost typographers and graphic designers including Neville Brody, Erik Spiekermann, David Berlow, Max Kisman, Erik van Blokland, Just van Rossum and Tobias Frere-Jones. Currently, the FontFont Library has approximately 2,000 fonts and continues to grow steadily. Their cutting edge designs break new ground in style, quality and innovation.

GarageFonts—http://www.garagefonts.com

GarageFonts was established in1993, primarily as a vehicle to distribute some of the first typefaces created for Raygun Magazine. From the beginning, GarageFonts has been on the cutting edge of new typeface design. Since its inception, GarageFonts has matured a bit (although they are constantly fighting the notion of growing up.) What started as a small library of trend-setting designs has grown to include more than 650 innovative text and display faces from a crew of stand-out international type designers, with many exciting new releases in the works. Their goal is to provide type lovers with a varied collection of original, accessible text and display typefaces. From slightly twisted traditional styles to the experimental and outrageously alternative designs you expect, GarageFonts has something for everyone.

Manfred Klein—http://www.manfredklein.de

Manfred Klein, born in Berlin in 1932, trained as a typographer and studied for several years with the famous type designer Günter Gerhard Lange. From 1956 to 1958 he continued his studies at the Meisterschule für Grafik und Buchgwerbe in Berlin. He worked as a typographer and creative director with AEG, Ogilvy & Mather and later headed his own advertising agency. Klein is the author of several enlightening publications on verbal and visual communication. Since 1990, he has developed a collection of influential and innovative typefaces and pi fonts. Klein remarks, "Typefaces are the atoms of human culture."

Lunchbox Studios—http://www.lunchboxstudios.com
http://www.reelhouse.com

LunchBox Studios is a new media and motion graphics firm located in Los Angeles, California. Their purpose is to produce reaction based solutions for the media: Broadcast Design, Web Graphics, Print, Corporate Identity, Collateral, Packaging, combined with an internationally distributed type foundry. This independent foundry showcases a blend of uniquely developed typefonts.

MyFonts.com, Inc.—http://www.myfonts.com

MyFonts.com, Inc., a venture funded by Bitstream Inc. and established as a wholly owned subsidiary in 1999, is a showcase of the world's fonts available from one easy-to-use internet portal. It provides the largest collection of typefonts ever assembled for online delivery, offering easy ways to find and purchase fonts on the web, unique typographic resources, and a forum for interacting with typography experts. MyFonts.com—the website for finding, trying and buying fonts online.

Nekton Design—http://www.donbarnett.com

Nekton Design, is essentially an illustration and design company created by Don Barnett. This includes type design, illustration and some animation created for both corporate clients and small businesses. The focus of Nekton Design is not one of type design or illustration but rather the search for interesting projects and people to develop them.

P22 Type Foundry—http://www.p22.com

P22 Type Foundry is dedicated to producing quality art and computer-related products. Their goal is to revive historical forms and present them in a contemporary, relevant form. P22's research and design teams are committed to developing typefaces that are not available anywhere. Their fonts represent a cross section of art, natural science and history in a context that is relevant to the modern computer user. Each font set is packaged with background information revealing its source and inspiration. P22 works with museums and foundations toward an accurate representation of history and art in their products, and strives to make them accessible to users at all levels.

Fabrizio Schiavi—http://www.fsd.it

The philosophy of Fabrizio Schiavi's designed fonts can be summarized in two words: experimental and functional. Although a majority of Schiavi's fonts are experimental, he is often more interested in the esthetic development of a font concept rather than in the result. These fonts have no commercial objective, even though they are often parodies of existing fonts, and are often created for use in his graphic design work. Recently Schiavi has designed more traditional fonts whose objectives are to have better readability for lowercase and monitor clarity.

Shift—http://www.shiftype.com

Conceived in 1993 by Joshua Distler as a way of marketing fonts created for his personal projects, Shift went online in 1995 to begin sales and distribution. For more than 5 years, Shift has been offering a small library of award winning fonts with predominantly technological themes, rendered in clean, thoughtful and original drawings. In September of 1998, the Shift website was re-launched with a new site, new fonts, new packaging, and the option to purchase and download fonts online.

[T-26] Type Foundry—http://www.t26.com

In 1994, [T-26] digital type foundry was created by Carlos Segura to explore the typographical side of the design world. His goal "was to bring about change, expanding the perimeters of the industry from within." Segura maintains that concept, demographics and objective are the primary focus of his work. The idea was to produce affordable fonts that promote experimentation in typeface design, highlight upcoming and student designers and open minds. [T-26] differs from existing type foundries in its marketing and the benefits afforded to both artists and customers. [T-26] remains a top choice for experimental, techno and modern fonts, and encompasses the work of prominent type designers including Margo Chase, Stephen Farell, Adam Roe, Rian Hughes and Chank.

Type[A] Digital Foundry—http://www.TypeA.com.au

Type[A] Digital Foundry promises relief for jaded palates bored with current type offerings. It is Australia's first digital type foundry, publishing and distributing innovative and exciting Australian designed typefaces. Type[A] is committed to the development and promotion of Australian typefaces. The work of other Australian typeface designers is added to the online foundry on a quarterly basis. The typefaces in their collection have been used by designers in national and international advertising campaigns, product packaging, magazines and books. Type[A] digital foundry was established in 1997 by graphic designers Lewis Tsalis and Damien Mair and has offices in the Australian capital cities of Sydney and Adelaide.

FONT SHOWCASE

Font Name
Air Mail Postage

Font Families
Air Mail Postage
Air Mail Regular

Elements
69

Style
Abstract
Directional
Geometric
Insignias
Mechanical
Pictorial
Postage
Stamping

Showings Page
106

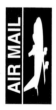

AIR MAIL POSTAGE

Adam Roe *United States*

Air Mail Postage is an experimental font designed by Adam Roe of Lunchbox Studios. It is composed of all the cancellation stamping details from Lunchbox Studios' correspondence over a one month period. The set contains a full array of mailing stamp ephemeral icons designed to decorate and embellish including C.O.D, Hand Deliver, Air Mail, Glass, Handle With Care and many circular cancellations insignias. Air Mail Postage has a full character matching letterform font, named Air Mail Regular.

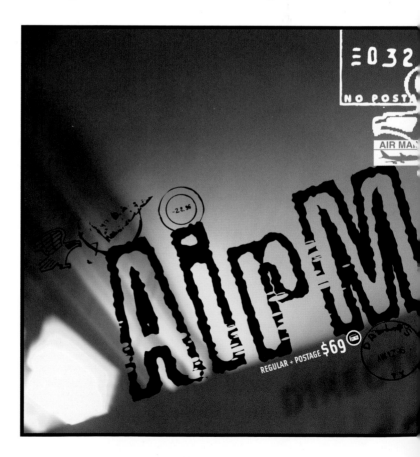

PURCHASE ONLINE AT: **http://www.lunchboxstudios.com**
http://www.reelhouse.com

Graphic Design ▷
Adam Roe

Purpose
**Film
Advertisement**

Graphic Design ▽
Adam Roe

Purpose
**Promotional
Mailer**

ALIENS

Font Name
Aliens

Font Families
Aliens Original
Aliens Head & Feeters
Aliens Constructed

Elements
180

Style
Artistic
Faces
Masks
Mythological

Showings Page
107

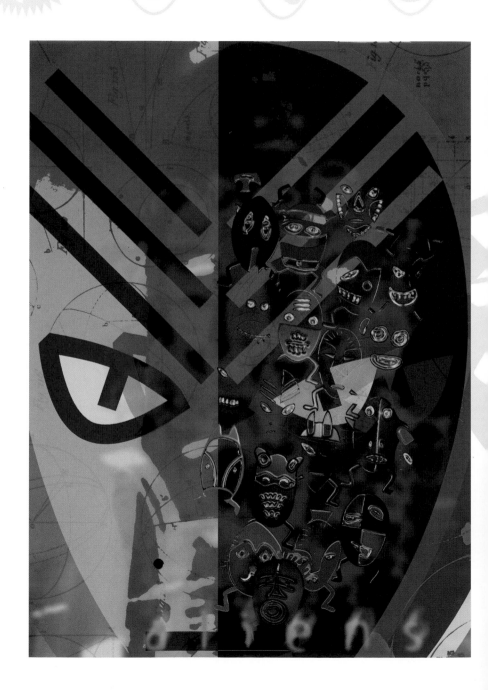

PURCHASE ONLINE AT: **http://www.ef-fonts.de**

Manfred Klein *Germany*

Aliens, designed by Manfred Klein, was created directly on a Wacom pad. The theme of Klein's dingbat font was Aliens invading the keyboard. Actors are changed into other human beings wearing masks. Once masked, they mutate into other people and play other characters. Humans assume that living beings from other worlds look like the masked human beings that are a tiny bit strange and always peculiar! Each letter represents a strange entity who has invaded your keyboard. There are 180 elements comprising three versions including Aliens Original, Aliens HeadFeeters (with feet) and Aliens Constructed.

Graphic Design ◁
Manfred Klein
Deborah Davis

Purpose
Typeface
Promotion

Graphic Design ▷
Manfred Klein
Deborah Davis

Purpose
Experimental

ASTOUND DINGS

Font Name
Astound Dings

Elements
94

Style
Astrological
Cosmic
Faces
Nuclear
Retro
Robotic
Science Fiction
Space Age
Spirals
Stars

Showings Page
109

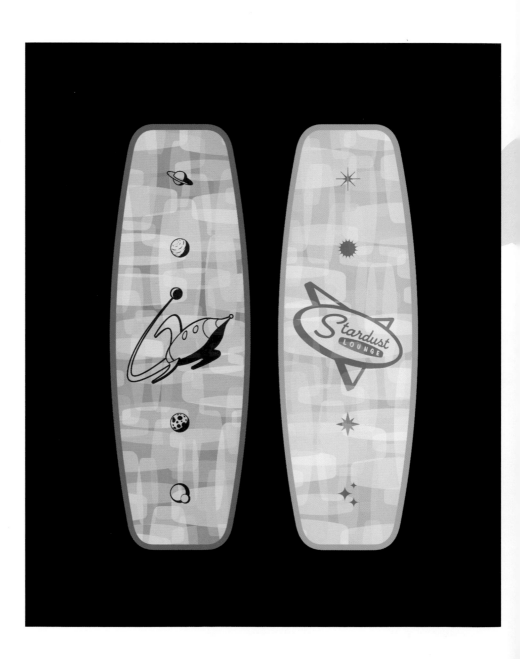

PURCHASE ONLINE AT: **http://www.garagefonts.com**

Dave Bastian *United States*

Astound Dings is an eclectic mix of elements reminiscent of the 50's TV generation that undoubtedly stems from designer Dave Bastian's preoccupation with space-age styling. This American pop culture font is derived from googie architecture, tailfin cars and funky Formica countertops. It is fused with pulp science fiction and B-grade sci-fi movie icons that portray a comic book attitude.

Graphic Design ◁
Dave Bastian

Graphic Design ▽
Tamye Riggs

Purpose
**Typeface
Promotional
Poster**

Purpose
**Typeface
Promotional
Postcard**

ASTOUND DINGS————

Font Name
Atomica

Elements
63

Style
Cosmic
Nuclear
Science Fiction
Space Age

Showings Page
110

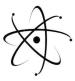

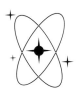

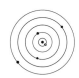

ATOMICA

Richard Kegler *United States*

Atomica, designed by Richard Kegler from the P22 Type Foundry, looks back to the start of the atomic energy era when fall-out shelters were highly fashionable. This nuclear font contains 63 atomic age symbols and Civil Defense emblems which are interpreted in an accompanying chart. Most of the font set features an array of Atomica icons that compose the protons, electrons and neutrons revolving around atoms in elliptical orbits. In addition, there is a variety of radioactive insignias.

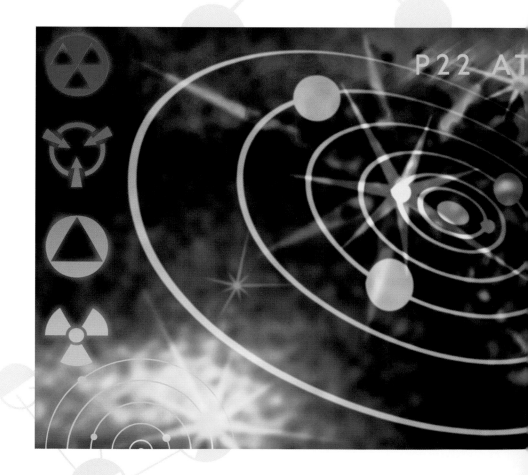

PURCHASE ONLINE AT: **http://www.p22.com**

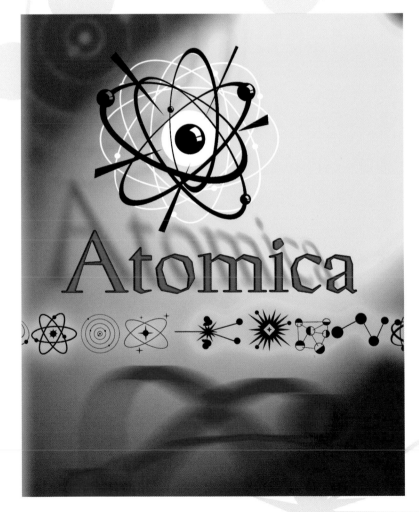

Graphic Design ◁
James Grieshaber

Graphic Design △
Richard Kegler

Purpose
Experimental

Purpose
Experimental

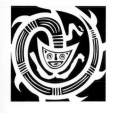

BEFORE THE ALPHABETS

Font Name
Before The Alphabets

Font Families
Before the Alphabets One

Before the Alphabets Two

Elements
65

Style
Aboriginal Primitive

Showings Page
111

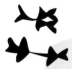

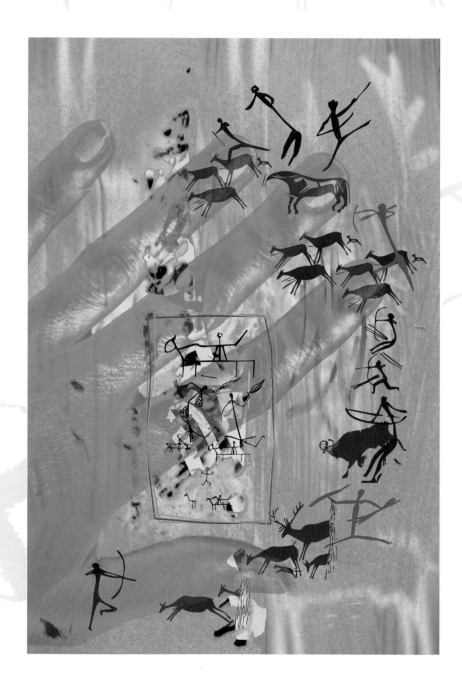

PURCHASE ONLINE AT: **http://www.ef-fonts.de**

Manfred Klein *Germany*

Graphic Design ◁
Deborah Davis

Purpose
Experimental

Graphic Design ▽
Deborah Davis

Purpose
**Typeface
Promotion**

Manfred Klein designed Before The Alphabets One and Before The Alphabets Two to pay homage to our early primitive colleagues. The first humans, who made the first pictographic character paintings on cliffs, illustrated how they lived, hunted and were hunted. The font consists of 130 primitive characters depicting hunting, foraging and celebrations of early life, derived from original cave drawings. Klein attributes to these early artists our knowledge of their time, how everything began, and why in today's asphalt jungle, we too are sometimes on the hunt.

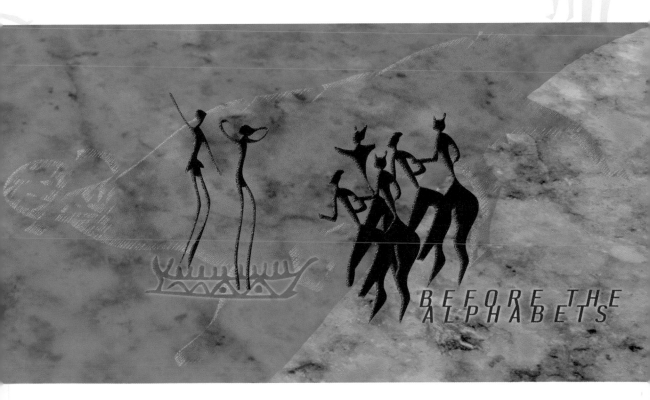

Font Name
Behind Bars

Elements
74

Style
Faces
Hand Drawn
Legal
Pictorial
Political

Showings Page
113

BEHIND BARS

Rodney Shelden Fehsenfeld *United States*

"We're all guilty," insists Behind Bars designer Rodney Shelden Fehsenfeld. This politically incorrigible font features the best and the worst of the worst. From clueless Clinton to ruthless Manson, this font is the most wanted for its contemptuous icons of infamous politicians, criminals and type designers. Complete with prison bars iconography, Behind Bars is sure to make a notable impact. This pictorial typeface contains more than 60 of your favorite delinquents. Don't forget—with each escaped parolee, a new font is released!

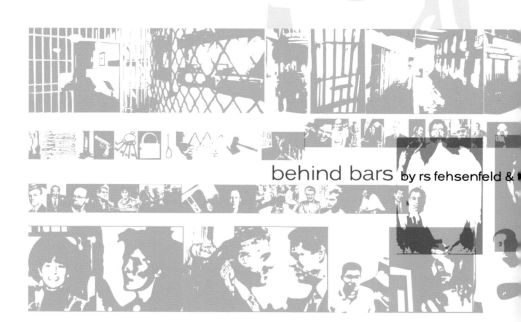

behind bars by rs fehsenfeld &

politicians, criminals + type designers

PURCHASE ONLINE AT: **http://www.garagefonts.com**

Graphic Design ▷
**Rodney Shelden
Fehsenfeld**

Purpose
**Typeface
Promotional
Poster**

Graphic Design ▽
**Rodney Shelden
Fehsenfeld**

Purpose
**Typeface
Promotional
Poster**

BEHIND BARS by rs fehsenfeld & tamye riggs

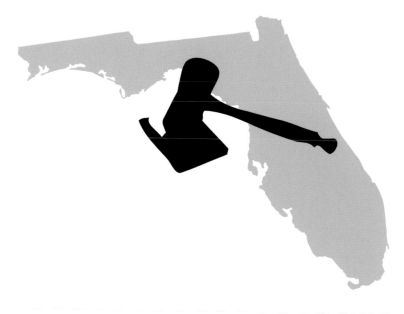

riggs

POLITICIANS, CRIMINALS + TYPE DESIGNERS

Font Name
Bioprosthesis

Elements
126

Style
**Anatomical
Science Fiction**

Showings Page
114

BIOPROSTHESIS

Tsuyoshi Nakazako *Japan / United Kingdom*

The imagery of bionic body parts with multi-optional assembling possibilities has been a recurring theme in the world of Japanese Anime. Designer Tsuyoshi Nakazako was born without fully developed fingers on his left hand. The mechano-biological development of high-tech prostheses has invoked a lifelong attraction for the artist. The focal point in the design of Bioprosthesis was to create imaginary replacement modules which emphasized the constructed architectural quality of the prototype units, in the context of original Anime replication. This unique robotic anatomical font contains 126 elements.

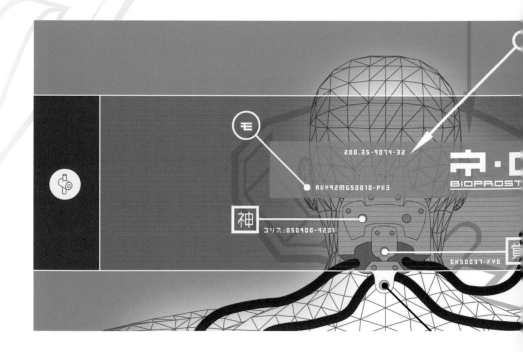

PURCHASE ONLINE AT: **http://www.plusism.com**

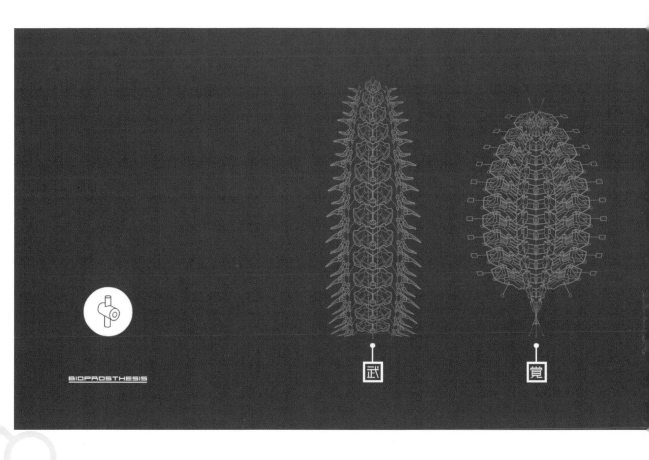

BIOPROSTHESIS

武

賞

Graphic Design △
Tsuyoshi
Nakazako

Purpose
Digital Font
Catalogue
Presentation

Graphic Design ◁
Tsuyoshi
Nakazako

Purpose
Digital Font
Catalogue
Presentation

BIOPROSTHESIS

Font Name
Buch Zeichen

Elements
65

Style
Artistic

Showings Page
115

BUCH ZEICHEN

Graphic Design ▽
Deborah Davis

Graphic Design ▷
Deborah Davis

Purpose
**Typeface
Promotion**

Purpose
**Typeface
Promotion**

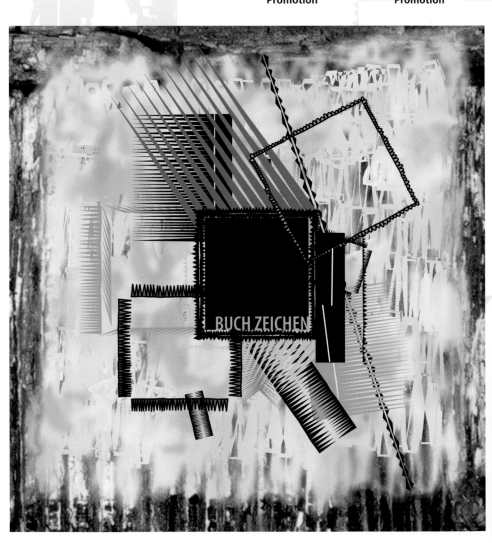

PURCHASE ONLINE AT: **http://www.ef-fonts.de**

Manfred Klein *Germany*

Buch Zeichen is an experimental font of book symbol pictograms designed by Manfred Klein. The symbol is an interpretation that originated as shadows of books, open books, book marks and printed pages, that later evolved into characters displaying tri-split and cloven compositions. The 65 literary elements portray artistic representations of bound pages, galleys and spreads. The set also includes several typeshop pictograms illustrating the original printing press icons.

BUCH ZEICHEN

Font Name
Buzzcog[A]

Elements
56

Style
Circular
Gears
Geometric
Mechanical

Showings Page
116

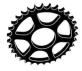
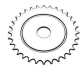
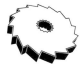

BUZZCOG[A]

Lewis Tsalis *Australia*

Buzzcog[A] is a collection of buzzsaw and gear cog symbols designed by Lewis Tsalis. These images were created after many visits to junk yards, workshops and tool sheds. After drawing several dozen buzzcogs over a two year period, the most interesting 26 were chosen for the final font. Each of these unique symbols have been extruded and silhouetted to provide a pseudo three-dimensional alternative with the keys [Shift + Letter]. Four additional elements were made in reverse that include [Shift + Option A], [Shift + Option C], [Shift + Option F] and [Shift + Option H].

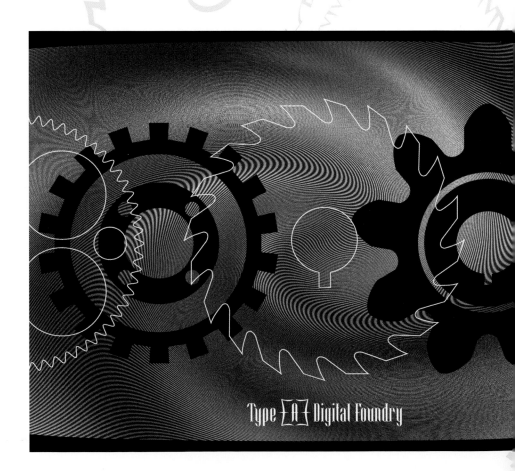

Type [A] Digital Foundry

PURCHASE ONLINE AT: **http://www.TypeA.com.au**
http://www.t26.com

Graphic Design ◁
Lewis Tsalis

Purpose
Io newsletter

Graphic Design ▷
Lewis Tsalis

Purpose
Type[A]
Promotional
Postcard

BUZZCOG[A]

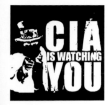

C.I.A. DEPARTMENT

Font Name
C.I.A. Department

Font Families
C.I.A. Department
C.I.A. Medium
C.I.A. Medium Oblique
C.I.A. Bold

Elements
42

Style
Faces
Historical
Insignias
Military
Pictorial
Political

Showings Page
117

Thomas Schostok *Germany*

Designer Thomas Schostok wanted to invent a headline font with a nearly emotionless character, in the same vein as DIN-Mittelschrift. In the spirit of a typical low budget film, Schostok designed and constructed the letterform using bad and irregular variants. After developing C.I.A. Medium, C.I.A. Medium Oblique and C.I.A. Bold, Schostok created C.I.A. Department, a companion dingbat bonus font. This "Top Secret" typeface has 42 images or enigmas about the Central Intelligence Agency. Be aware that C.I.A. Department contains some piece of authentic confidential history from Castro to JFK.

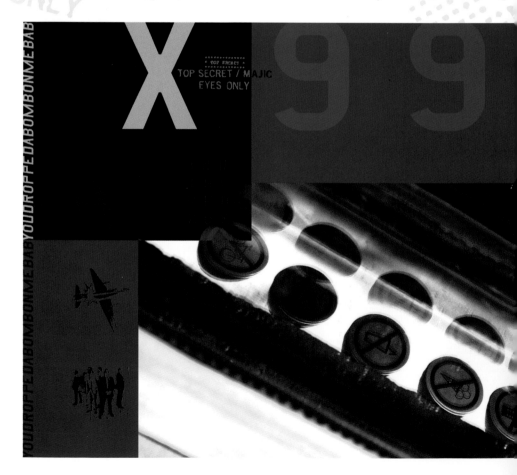

PURCHASE ONLINE AT: **http://www.garagefonts.com**

Graphic Design ▷
Thomas Schostok

Purpose
**Typeface
Promotional
Poster**

Graphic Design ▽
Tamye Riggs

Purpose
**Typeface
Promotional
Postcard**

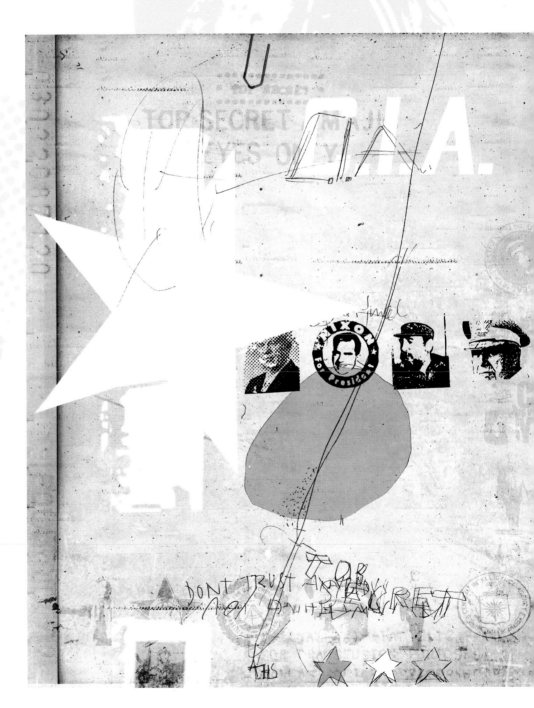

DOTTO

Font Name
Dotto

Font Families
Dotto One
Dotto Too
Dotto Alphabet

Elements
100+

Style
Dots
Pictorial

Showings Page
118

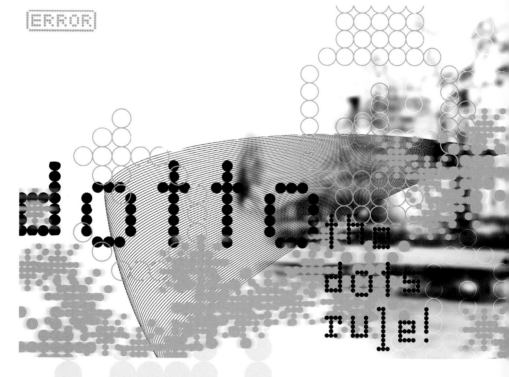

PURCHASE ONLINE AT: **http://www.t26.com**
http://www.behaviourgroup.com

Anuthin Wongsunkakon *Thailand*

Certainly a dot font is not a unique idea in typeface design. Dotto, designed by Anuthin Wongsunkakon contains a family of two sets of icon designs, Dotto One and Dotto Too, plus a bonus alphabet, Dotto Alphabet. Using the same dot matrix grid design, the alphabet works well with the dotted icon fonts. More than 100 elements comprise the pictorial images that include light bulbs, envelopes, computer disks, bells, electronics and directional arrows.

Graphic Design ◁
**Nirut
Krusuansombat**

Purpose
Promotion Poster

Graphic Design ▷
**Nirut
Krusuansombat**

Purpose
Promotion Poster

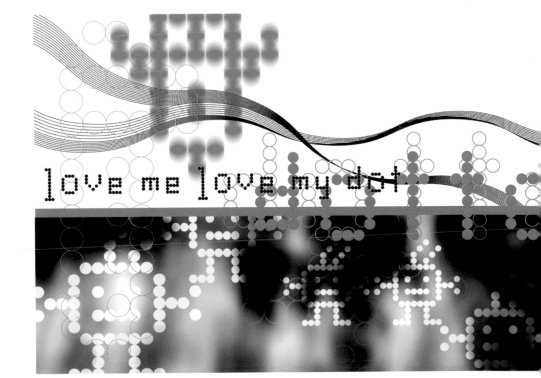

DOTTO

Font Name
Ethno Paintings

Elements
65

Style
Aboriginal
Ancient
Animals
Birds
Figurative
Primitive

Showings Page
120

ETHNO PAINTINGS EF

Manfred Klein *Germany*

Ethno Paintings EF designed by Manfred Klein depicts primitive cave illustrations. These aboriginal illustrations documenting early human civilization, represent inspirational influences at the dawn of the prehistoric era. Cross-cultural cave drawings have been taken from historic resources worldwide to form a diverse compilation of iconic ethnography. The 65 heterogeneous elements include an eclectic mix of animals, ethnic figures, ritual masks and symbolic pictograms.

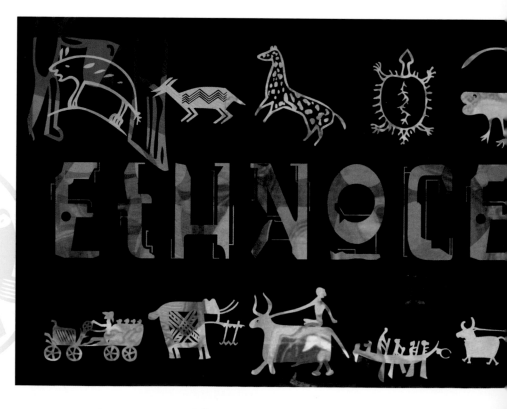

PURCHASE ONLINE AT: **http://www.ef-fonts.de**
http://www.myfonts.com

Graphic Design ▷
Tamye Riggs

Purpose
**Typeface
Promotional
Poster**

Graphic Design ◁
Tamye Riggs

Purpose
**Typeface
Promotional
Postcard**

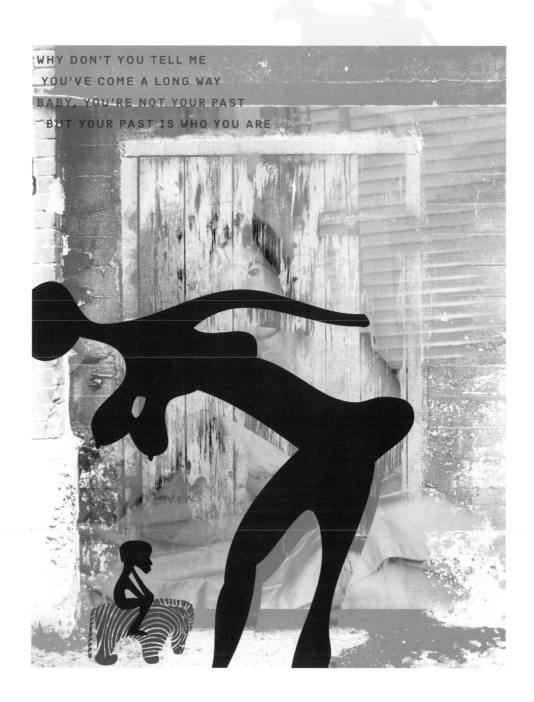

WHY DON'T YOU TELL ME
YOU'VE COME A LONG WAY
BABY, YOU'RE NOT YOUR PAST
BUT YOUR PAST IS WHO YOU ARE

ETHNO PAINTINGS EF ———————

Font Name
Flying Objects

Elements
84

Style
Birds

Showings Page
121

FLYING OBJECTS

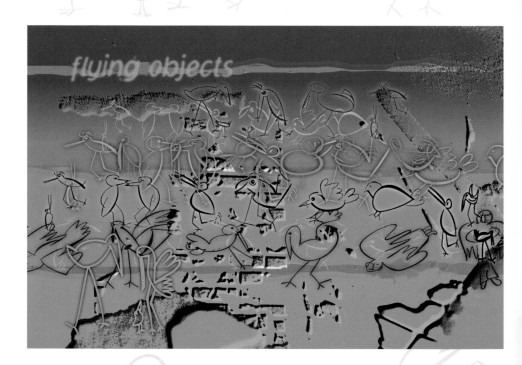

Graphic Design △
Kathleen Ziegler
Deborah Davis

Purpose
Typeface
Promotional
Postcard

Graphic Design ▷
Kathleen Ziegler
Deborah Davis

Purpose
Experimental

PURCHASE ONLINE AT: **http://www.ef-fonts.de**

Manfred Klein *Germany*

Many people often dream of simply taking to the air and flying. Few know that birds are descendants of flying dinosaurs. Is this a sufficient reason for developing a bird theme font? Manfred Klein designed Flying Objects with this in mind. There are 84 carefully hand-drawn characters and associates in this playful typeface set including birds in flight, walking, singing, bathing and kissing. This lighthearted font is for the ornithologist at heart.

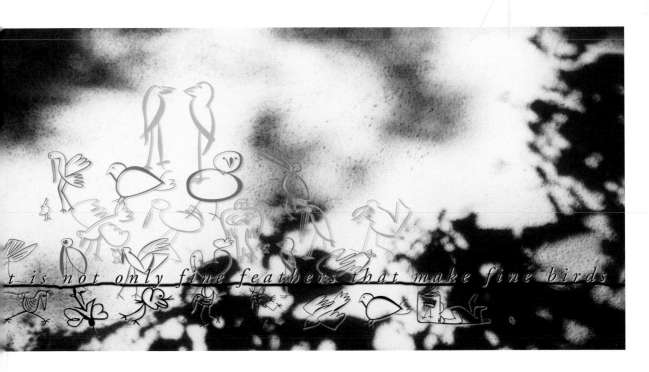

FLYING OBJECTS

Font Name
Flying OpArt

Elements
80

Style
Artistic
Geometric

Showings Page
122

FLYING OPART

Manfred Klein *Germany*

Flying OpArt, designed by Manfred Klein, is a cleverly illustrated font whose origin dates back to the OpArt of the 60s. Klein drew inspiration from one of the masters of warped squares, V. Vasarely, a Hungarian painter from France. With this font, his work becomes OpArt kites. Like delicate optical illusions floating in space, there are 80 different artistic geometric abstractions from which to choose. Klein jokes, "Now, a few dozen flying OpArts wait beneath the keys of your computer, ready to enrich your texts with their forms."

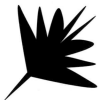

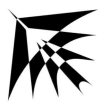

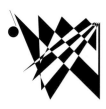

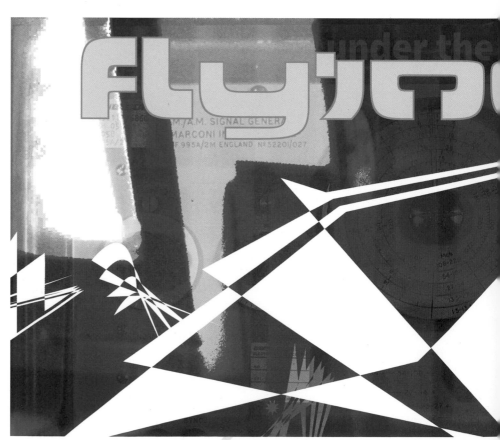

PURCHASE ONLINE AT: **http://www.ef-fonts.de**

Graphic Design ◁
Tamye Riggs

Graphic Design △
Angus R. Shamal

Purpose
Typeface
Promotional
Postcard

Purpose
Typeface
Promotional
Poster

FLYING OPART ———— 43

FRANK LLOYD WRIGHT TERRACOTTA EXTRAS

Font Name
Frank Lloyd Wright Terracotta Extras

Font Families
FLLW Terracotta Extras

FLLW Terracotta Regular

FLLW Terracotta Alternates

Elements
102

Style
Abstract Geometric Organic

Showings Page
123

Christina Torre, Frank Lloyd Wright *United States*

Frank Lloyd Wright Terracotta Extras accompanies the Frank Lloyd Wright Terracotta Regular and Alternates font sets. There are 102 elements in this Extras font set, the third in the P22 Type Foundry's Wright series. All are derived from letterforms and decorative embellishments found in Wright's early work (1893–1910), and in his book, The House Beautiful (1896–97). Wright based the delicate graphic designs on stylized natural plant forms. Terracotta users can now adorn their designs with these inspiring motifs.

PURCHASE ONLINE AT: **http://www.p22.com**

Graphic Design ▷
Cristina Torre

Purpose
Experimental

Graphic Design ▽
Cristina Torre

Purpose
Experimental

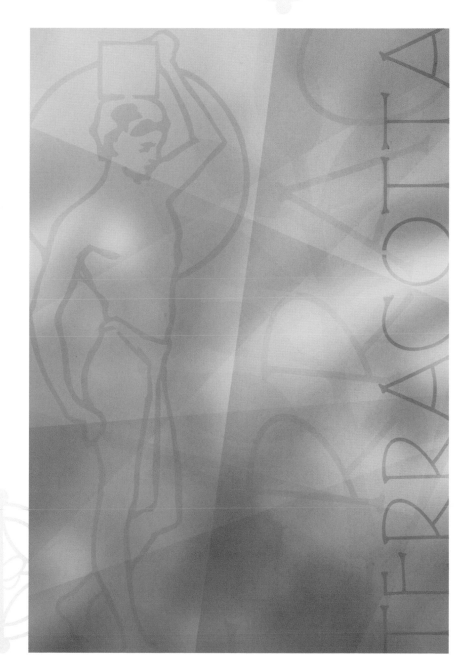

FRANK LLOYD WRIGHT TERRACOTTA EXTRAS

Font Name
Fontology-E

Elements
245

Style
Artistic

Showings Page
124

FONTOLOGY-E

PURCHASE ONLINE AT: **http://www.fsd.it**

Fabrizio Schiavi *Italy*

Fontology-E is an experimental font designed by Italian designer Fabrizio Schiavi. It was created for the cover of the Fontology catalogue. Schiavi's need was to build an optical false modulation effect with versions of the logotype and typical rectangles of an empty font chart. The basic idea was to create a page that contained many rectangles in order to demonstrate the modulation. At the same time, it was important to understand that Schiavi inserted 8 versions of the same logotype each time the corresponding letter is digitized in e, a, d, f, g, h, c and b. The inside of the catalogue has the same layout and text, which is revealed by fanning the pages. Schiavi confesses that Fontology-E is a highly experimental typefont.

Graphic Design ◁
Fabrizio Schiavi

Purpose
Postcard

Graphic Design ▷
Fabrizio Schiavi

Purpose
Postcard

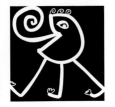

Font Name
Gois

Elements
52

Style
Artistic
Hand Drawn
Science Fiction

Showings Page
125

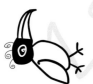

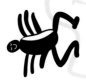

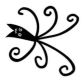

GOIS

Manfred Klein *Germany*

Gois is a hand-made whimsical font designed by Manfred Klein. All the characters were drawn directly onto a Wacom pad, using Macromedia's Fontographer on the Macintosh. This technique involved the use of a pressure-sensitive stylus for variable line weights. Once the initial illustrations were finished, each required substantial polishing to complete. The 52 element set includes capriciously drawn people, animals, heads, hands, legs and peculiar creatures.

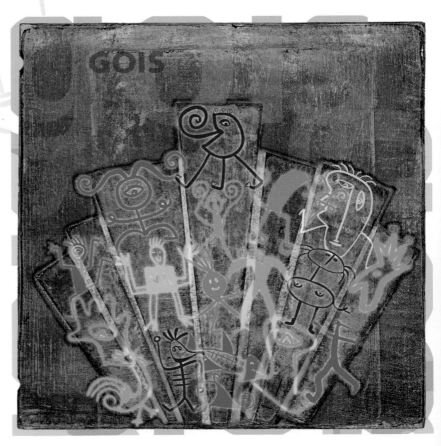

 PURCHASE ONLINE AT: **http://www.ef-fonts.de**

Graphic Design ◁
Deborah Davis

Graphic Design ▽
Deborah Davis

Purpose
**Typeface
Promotion**

Purpose
Experimental

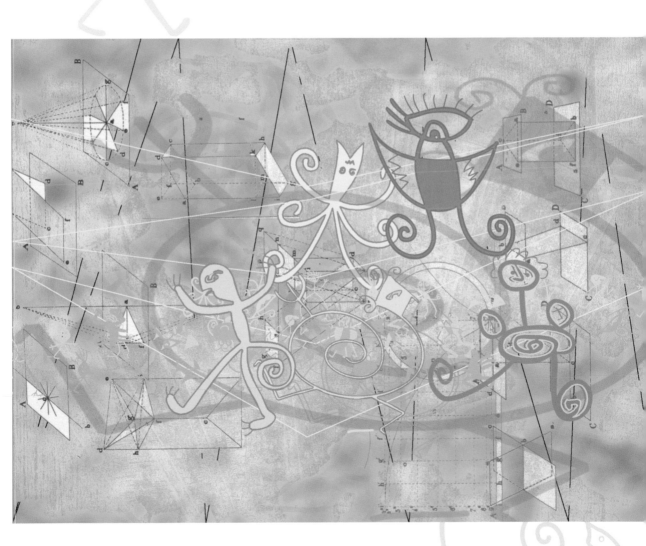

HIEROGLYPHS

Font Name
Hieroglyphs

Font Families
Hieroglyphic Cartouche
Hieroglyphic Decorative
Hieroglyphic Phonetic

Elements
280

Style
Ancient Hieroglyphic

Showings Page
126

Denis Kegler, Carima El-Behairy, Richard Kegler *United States*
Hieroglyphs was a pictorial alphabet used in ancient Egypt from 3100 BC to approximately 300 AD. This font set features 280 different pictographs, plus an extensive translation chart. The Hieroglyphic font, from the P22 Type Foundry, adapts one of the world's oldest forms of art and communication to today's technology. The families include Hieroglyphs Phonetic, Hieroglyphs Decorative and Hieroglyphs Cartouche pictographic scripts.

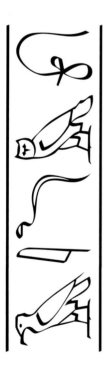

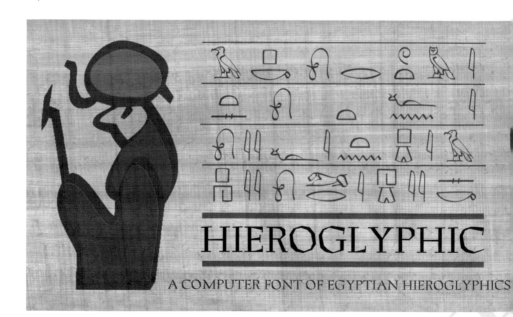

HIEROGLYPHIC

A COMPUTER FONT OF EGYPTIAN HIEROGLYPHICS

Graphic Design ▷
James Grieshaber

Purpose
Experimental

Graphic Design ▽
James Grieshaber

Purpose
Experimental

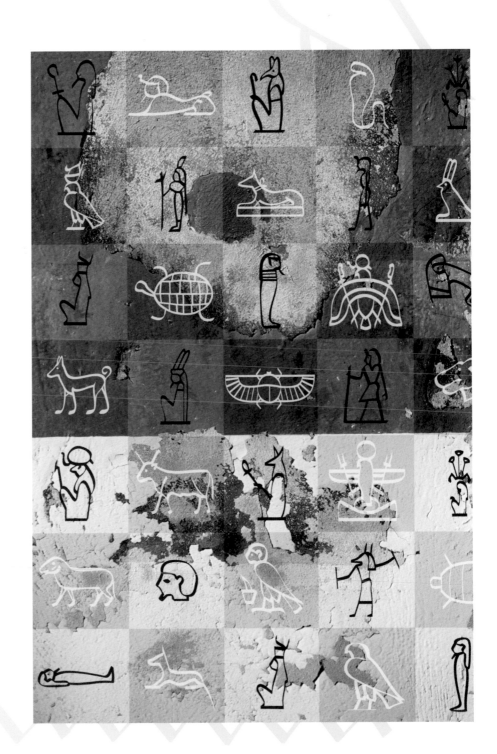

HIEROGLYPHS

Font Name
HubaHuba

Elements
101

Style
Circular
Hubcaps
Mechanical
Spirals

Showings Page
129

HUBAHUBA

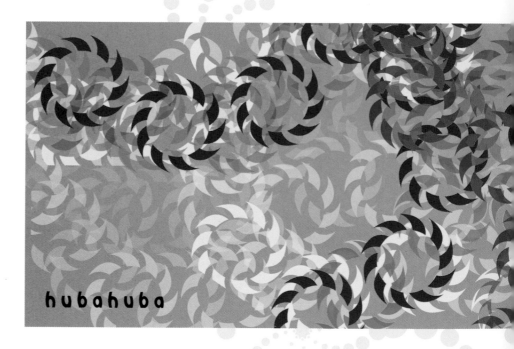

hubahuba

PURCHASE ONLINE AT: **http://www.garagefonts.com**

Hans G. Meier *Norway*

Norwegian graphic designer Hans G. Meier's prize-winning font
was inspired by the long tradition of American automobile
hubcaps. Meier found many new design ideas rolling around
every corner. Circular and balanced, these graphic spirals offer
101 motif possibilities. In 1997, HubaHuba was awarded First
Place, Dingbat Category, in the GarageFonts/Macromedia
International Font Design Contest.

Graphic Design ◁
Felicia Anggoro

Purpose
**Typeface
Promotional
Postcard**

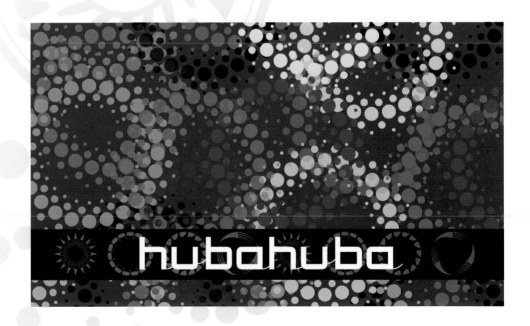

Graphic Design ▷
Felicia Anggoro

Purpose
**Typeface
Promotional
Postcard**

Font Name
Hugi Pictural

Font Families
Hugi Pictural
Hugi Literal

Elements
89

Style
Abstract
Anatomical
Artistic
Cosmic
Faces
Hand Drawn
Organic
Pictorial
Primitive
Stars

Showings Page
130

HUGI PICTURAL

Hugi Hugel *Germany*

German artist Hugi Hugel designs pictures. A recent project entailed creating a kitchenware collection. While never intending to produce typefaces, studio partner Thomas Schnäbele asked him to paint icons from his work. Then, Schnäbele used the art to digitize the font. Hugel claims that the pictures on display are the source of his inspiration. The icons in Hugi Pictural are "the kids of my larger designed pictures," says Hugel. In 1997, Hugi Pictural was awarded Second Place, Dingbat Category, in the GarageFonts/Macromedia International Font Design Contest.

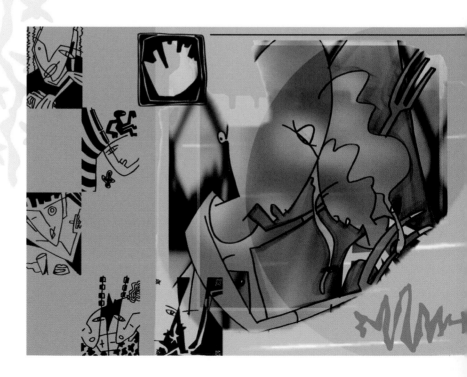

Graphic Design ▷
Natalie Lee

Purpose
Typeface
Promotional
Postcard

Graphic Design ▽
Hugi Hugel

Purpose
Typeface
Promotional
Postcard

HUGI PICTURAL

IL FUTURISMO EXTRAS

Font Name
Il Futurismo
Extras

Font Families
Il Futurismo
Extras

Il Futurismo
Regular

Il Futurismo
Velocità

Elements
52

Style
Abstract
Geometric
Political
Retro

Showings Page
131

Graphic Design ◁
Cristina Torre

Purpose
Experimental

Graphic Design ▷
Richard Kegler

Purpose
Experimental

PURCHASE ONLINE AT: **http://www.p22.com**

Alan Kegler *United States,* **Fortunado Depero** *Italy*

Italian Futurism (1908–43) was one of the 20th century's first and most influential avant-garde art movements. Futurist typography sought to disrupt traditional notions of harmony, space and composition on the printed page. Alan Kegler has interpreted the designs of Fortunado Depero in Il Futurismo Extras, an eclectic fusion of geometric, political, retro and abstractions, featuring 52 singular icons. The bold and jarring shapes of this set faithfully recall a tumultuous era in both Italian history and Italian graphic design. Il Futurismo Extras accompanies the Il Futurismo Regular and the Il Futurismo Velocità letterform font.

IL FUTURISMO EXTRAS

Font Name
Kells Extras

Font Families
Kells Extras
Kells Round
Kells Square

Elements
72

Style
Ancient
Geometric
Mythological

Showings Page
132

KELLS EXTRAS

Richard Kegler, Michael Want, David Setlik *United States*

The Book of Kells is a 9th century gospel created in the British Isles and is considered the finest existing example of early Celtic art. The original is housed in the Trinity College Library, Dublin. Kells was designed by the P22 Type Foundry to depict the extraordinary embellishments contained in the artwork. This computer set combines historical accuracy with functional readability and features an elaborate array of 72 decorative elements and linking ornamental borders.

PURCHASE ONLINE AT: **http://www.p22.com**

Graphic Design ▷
Cristina Torre

Purpose
Experimental

Graphic Design ▽
Richard Kegler

Purpose
Experimental

KELLS EXTRAS

KOCH BOOK OF SIGNS

Font Name
Koch Book of Signs

Font Families
Koch Signs One
Koch Signs Two
Koch Signs Three
Koch Signs Four
Koch Signs Five

Elements
360

Style
Abstract
Ancient
Astrological
Hand Drawn
Insignias
Mythological

Showings Page
133

Denis Kegler *United States,* **Rudolf Koch** *Germany*

Koch Book of Signs from the P22 Type Foundry was designed by Rudolf Koch and digitized by Denis Kegler. It is a reproduction of 360 of the signs contained in German typographer Rudolf Koch's work, The Book of Signs. The symbols include ancient astrological, Christian, Medieval and Runic iconography. The set also includes a PDF version of the original Book of Signs on CD, plus a new edition of Koch's famous original Neuland font. The new renamed P22 Koch Nueland features alternate characters designed originally in metal, but lost to subsequent digital versions.

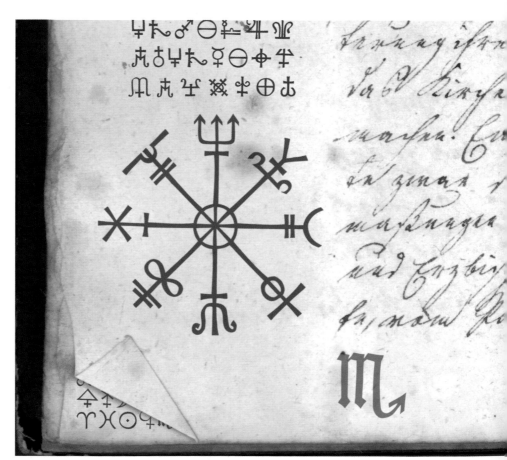

PURCHASE ONLINE AT: **http://www.p22.com**

Graphic Design ▷
Richard Kegler

Purpose
Experimental

Graphic Design ◁
James Grieshaber

Purpose
Experimental

Font Name
Larvae

Elements
62

Style
Abstract
Planktonic
Sea Life

Showings Page
138

LARVAE

PURCHASE ONLINE AT: **http://www.donbarnett.com**

Don Barnett *United States*

Larvae, designed by Don Barnett, was inspired by microscopic life forms and sea creatures. As an illustrator, Barnett finds it naturally intuitive creating symbolic fonts that balance symmetrical and asymmetrical designs with organic and geometric structures. This analogous font contains 62 fluid images that include wonderful flagellate organisms that represent planktonic sea life. Plankton-b is Barnett's companion letterform font.

Graphic Design ◁
Don Barnett

Purpose
**Digital Calendar/
Screen Saver**

Graphic Design ▷
Don Barnett

Purpose
**Digital Calendar/
Screen Saver**

ONLY $.187

Font Name
Lithium

Elements
54

Style
Artistic

Showings Page
139

LITHIUM

Fabrizio Schiavi *Italy*

Lithium, Italian designer Fabrizio Schiavi's first symbol font, was inspired by the famous Nirvana song. This experimental font is a typographic metaphor of mass media saturation depicting icongraphy as found on beer cans, detergent boxes and UPC codes. Segments of instructional text from the product packaging are included. Uppercase symbols are easily identified, while lowercase ones always overlap. The result is a hallucinogenic hybrid typefont.

PURCHASE ONLINE AT: **http://www.fsd.it**

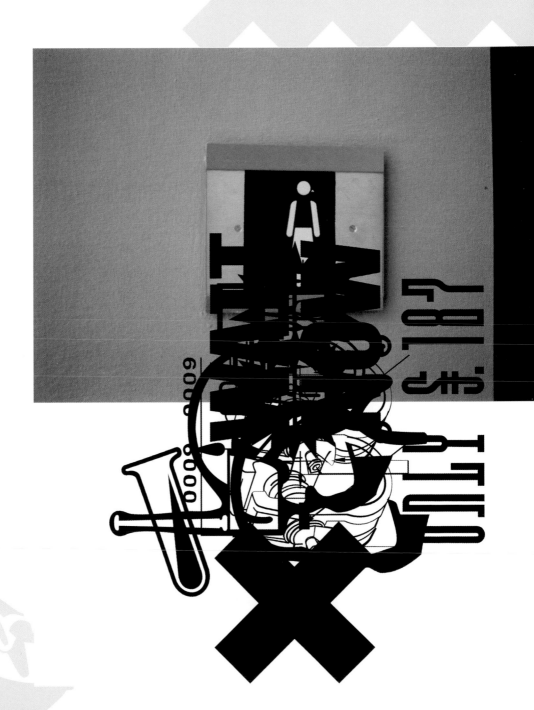

Graphic Design ◁
Fabrizio Schiavi

Purpose
Postcard

Graphic Design ▷
Fabrizio Schiavi

Purpose
Postcard

Font Name
Media Icons

Elements
156

Style
Circular
Directional
Geometric
Media
Mechanical
Techno

Showings Page
140

MEDIA ICONS

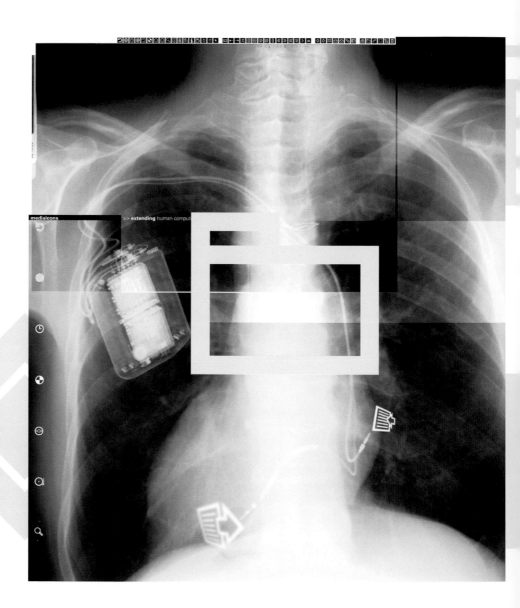

PURCHASE ONLINE AT: **http://www.garagefonts.com**

Graphic Design ◁
Chris Weiner

Purpose
Typeface
Promotional
Poster

Graphic Design ▷
Tamye Riggs

Purpose
Typeface
Promotional
Postcard

Chris Weiner *Germany*

While working on design projects for clients, German artist Chris Weiner wanted a contemporary font with very graphic navigational systems. To fulfill that need, he started inventing individual symbolic images. After designing a few symbols, he created a typeface that represented a collection of computer icon media images, and Media Icons was born. There are 156 geometric gems portraying on-screen icons that include envelopes, electronic products, directional arrows, pointing and grabber hands, a speaker, a cassette tape and the popular trash can icon.

CONNECTION TERMINATED DUE TO LACK OF ACTIVITY

THERE WAS NO RESPONSE FROM T

MEDIA ICONS

MICHELANGELO EXTRAS

Font Name
Michelangelo Extras

Font Families
Michelangelo Extras

Michelangelo Regular

Rodin Extras

Rodin Regular

Elements
26

Style
Artistic Hand Drawn

Showings Page
141

Denis Kegler *United States*

Michelangelo Extras, rendered by Denis Kegler from the P22 Type Foundry, has 26 reproduction sculptural and illustrated images from the immortal Italian artist, painter, and sculptor Michelangelo Buonarroti (1475–1564). The artistic set encompasses sculptural heads of David and the Pieta's Madonna, rose windows, plus an array of hands, including the Creation from the Sistine Chapel. The great French sculptor Francois Auguste Rodin (1840–1917) was strongly inspired by Michelangelo. Created in association with the Philadelphia Museum of Art, this font is a tribute to the achievements of the renowned artists. Michelangelo Extras accompanies the Michelangelo Regular letterform set that includes Rodin Extras and Rodin Regular.

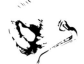

PURCHASE ONLINE AT: **http://www.p22.com**

Graphic Design ▷
Richard Kegler

Purpose
Experimental

Graphic Design ▽
Cristina Torre

Purpose
Experimental

MICHELANGELO EXTRAS

Font Name
Mode 01

Elements
158

Style
Artistic
Figurative

Showings Page
142

MODE 01

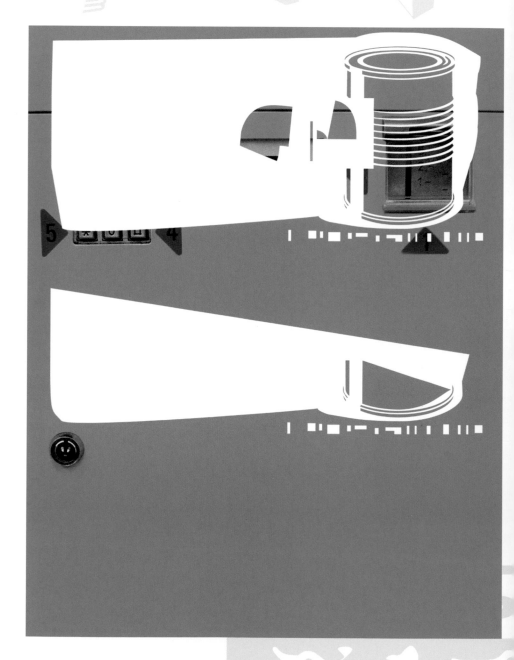

PURCHASE ONLINE AT: **http://www.fsd.it**
http://www.fontfont.com

Fabrizio Schiavi *Italy*

Mode 01, designed by Fabrizio Schiavi, is an experimental font where a symbol becomes a letter, and in a traditional interpretation, a letter becomes a symbol. The principle is similar to the "Kanji" alphabet in which figures designate words. For example "tree" is not represented by the letters (t, r, e, e,) but rather one symbol with a common interpretation. In Mode-01, an interpretation code is non-existent. The font is a hybrid alphabet based on the Western and Eastern writing systems. The letters that replace the Western alphabet become ideographs (logotypes). In addition, a, e, o, i and n, have been designed with ISO Latin accents. With Mode 01, Schiavi hopes to explore a hybrid form of writing using decontextualized ideograms.

Graphic Design ◁
Fabrizio Schiavi

Purpose
Postcard

Graphic Design ▷
Fabrizio Schiavi

Purpose
Postcard

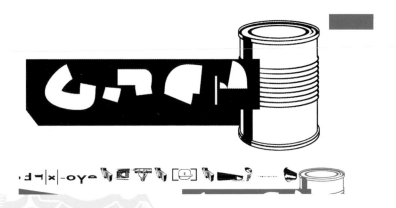

MODE 01

MONSOON

Font Name
Monsoon

Elements
100

Style
Weather

Showings Page
143

Nirut Krusuansombat *Thailand*

Monsoon, designed by Nirut Krusuansombat, was originally produced for CNN.com to create a new identity for their weather broadcast. The font was created for screen resolution viewing. The standard set contains the most common forecast signs representing weather around the world. There are numerous stylized atmospheric graphics including rain clouds, sunshine, thunder, lightening, snow, tornado and the infamous monsoon icon.

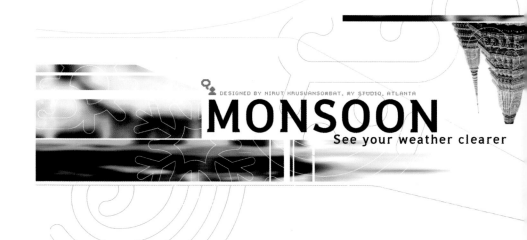

DESIGNED BY NIRUT KRUSUANSOMBAT, MY STUDIO, ATLANTA

MONSOON
See your weather clearer

PURCHASE ONLINE AT: **http://www.behaviourgroup.com**

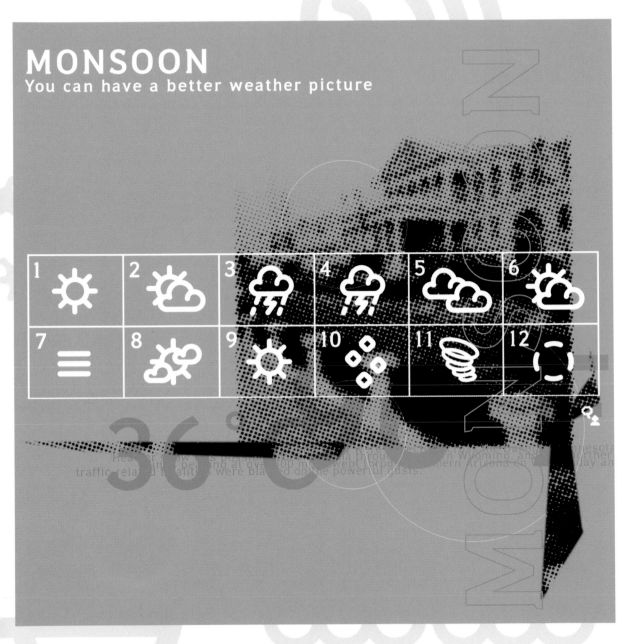

MONSOON
You can have a better weather picture

Graphic Design ◁
**Nirut
Krusuansombat**

Purpose
**Promotion Poster
and Postcard**

Graphic Design △
**Nirut
Krusuansombat**

Purpose
Promotion Poster

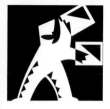

Font Name
Muscles

Elements
47

Style
Anatomical
Animals
Artistic
Birds
Retro

Showings Page
144

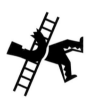

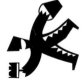

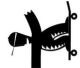

MUSCLES

Roberto Brunetti, Pierluigi Portolano *Italy*

Futurist artists were the inspiration for Italian designers Roberto Brunetti and Pierluigi Portolano's award winning font titled Muscles. "This font is a modern stylized expression of the poetic side of life," says Brunetti. The symbols in Muscles add humor and movement to a creative project. The main element is a lovable costumed character performing muscular tasks including carrying a ladder, painting, shooting an arrow, golfing and holding nautical flags. The typefont also includes several dogs, dinosaurs and assorted animals. Brunetti and Portolano produce innovative typefaces at Escogita, the Italian graphic design agency and type foundry the team co-founded in 1995. Muscles won first prize in the Pi Fonts category at Linotype-Hell's First International Digital Type Design Contest.

PURCHASE ONLINE AT: **http://www.garagefonts.com**

Graphic Design ▷
Felicia Anggoro

Purpose
**Typeface
Promotional
Poster**

Graphic Design ◁
Tamye Riggs

Purpose
**Typeface
Promotional
Postcard**

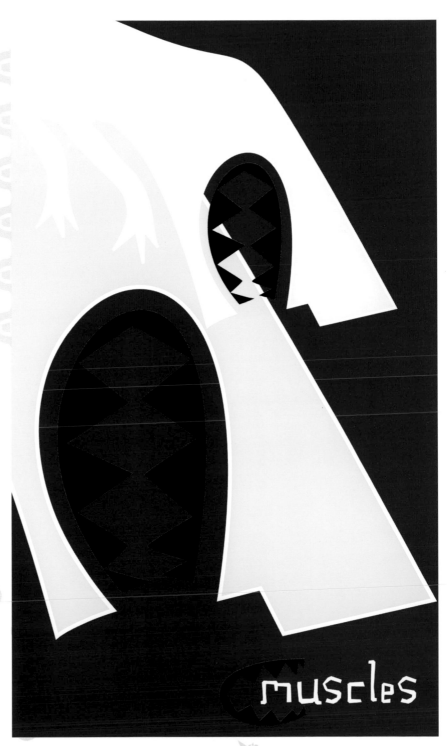

MUSCLES ————

Font Name
Oak Simblz

Elements
164

Style
Abstract
Anatomical
Artistic
Botanical
Circular
Cosmic
Directional
Hands
Mechanical
Military
Nuclear
Political
Stars

Showings Page
145

OAK SIMBLZ

Oliver A. Krimmel *Germany*

German designer Oliver A. Krimmel created the font Oak Simblz from familiar objects and icons. He carefully crafted each image by hand, then morphed the finished shapes into slightly more abstract forms. Oak Simblz features a variety of traditional symbols, including star bursts, arrows, globes and fleurons. A helicopter, clenched fist, skull and crossbones and nude human figures are among the 164 unusual elements found in this typeface.

PURCHASE ONLINE AT: **http://www.garagefonts.com**

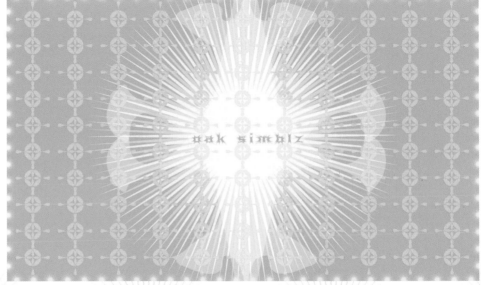

Graphic Design ◁
Felicia Anggoro

Purpose
Typeface
Promotional
Postcard

Graphic Design △
Felicia Anggoro

Purpose
Typeface
Promotional
Postcard

Font Name
Panspermia

Font Families
Panspermia Pos
Panspermia Neg
Panspermia Out

Elements
50

Style
Abstract
Hand Drawn
Organic

Showings Page
146

PANSPERMIA

PURCHASE ONLINE AT: **http://www.fontboy.com**

Bob Aufuldish *United States*

Panspermia, designed by Bob Aufuldish, is a series of dingbats derived from the backing sheet of a set of stickers. There are three versions. In all variations, the upper case is hand-drawn and the lower case is auto-traced. The differences are not apparent until the characters are enlarged. The Pos (positive) version represents the shapes and the Neg (negative) version denotes the shapes reversed out of a rectangle. The Out (outline) version shows the diversity between the hand-drawn and auto-traced versions, resulting in an outline. The name Panspermia comes from the idea that the earth was engendered by an extraterrestrial source from beyond the known solar system.

Graphic Design ◁
Bob Aufuldish

Purpose
**Promotional
Image for
Panspermia**

Graphic Design ▽
Bob Aufuldish

Purpose
**Beyond The
Margins of
the Page**

PANSPERMIA

Font Name
Petroglyphs

Font Families
**Petroglyphs
African**

**Petroglyphs
Australian**

**Petroglyphs
European**

**Petroglyphs
North American**

Elements
288

Style
**Aboriginal
Abstract
Anatomical
Ancient
Animals
Artistic
Birds
Cosmic
Figurative
Hand Drawn
Primitive**

Showings Page
149

PETROGLYPHS

Denis Kegler *United States*

The oldest known form of visual communication, rock art, expresses the culture and traditions of prehistoric man. The Petroglyphs picture font, designed by Denis Kegler from the P22 Type Foundry, presents ancient animal drawings, aboriginal figures and primitive hand-painted illustrations from the four continents. The font families contain 288 elements that include Petroglyphs African, Petroglyphs Australian, Petroglyphs European and Petroglyphs North American.

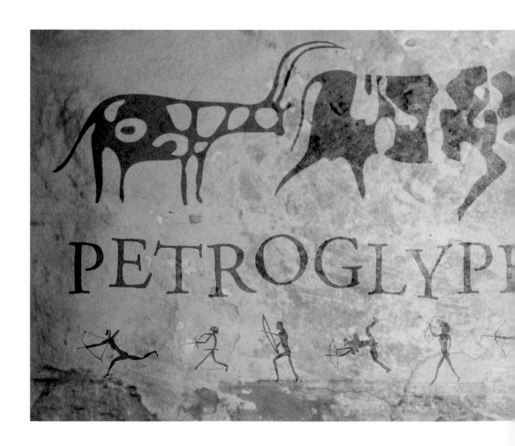

PURCHASE ONLINE AT: **http://www.p22.com**

Graphic Design ▷
James Grieshaber

Purpose
Experimental

Graphic Design ▽
James Grieshaber

Purpose
Experimental

PETROGLYPHS

Font Name
Phantomekanix

Elements
62

Style
Cosmic
Gears
Geometric
Mechanical
Robotic
Science Fiction
Space Age
Techno

Showings Page
153

PHANTOMEKANIX

Marcus Burlile *United States*

American type designer Marcus Burlile's inspiration for Phantomekanix evolved from his interest in comic book monsters and fiendish science fiction robots from outer space. "Their ultimate plot is total destruction and deceit. The purpose is to integrate them into the population indiscreetly. Beware of the paranoia lurking all around us…" says Burlile. The 62 robotic creatures stand on call with clasping arms extended, ready to fill the niche for the sci-fi aficionado.

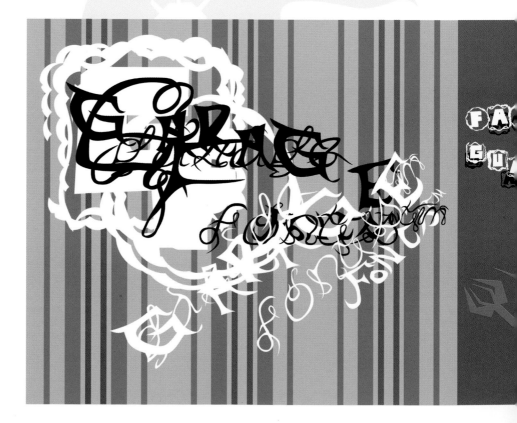

PURCHASE ONLINE AT: **http://www.garagefonts.com**

Graphic Design ▷
Tamye Riggs

Purpose
**Typeface
Promotional
Poster**

Graphic Design ▽
Marcus Burlile

Purpose
**Typeface
Promotional
Postcard**

THE ALIEN THAT ATE HOLLYWOOD
A HISTORY OF MONSTERS IN THE MOVIES
BY HERBERT LIEBOWITZ

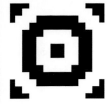

PIXXO

Font Name
Pixxo

Elements
80

Style
Pixel

Showings Page
154

PURCHASE ONLINE AT: **http://www.behaviourgroup.com**

Nirut Krusuansombat *Thailand*

Nirut Krusuansombat was inspired by digital generic and computer terminology to design a pixel format font called Pixxo. This typeface was aptly named because of the bit-mapped construction and is a companion font to the artist's dot matrix font, titled Dotto. Originally used as an in-house picture font, Pixxo became an instant icon symbol for on web design based pixel screen values. The typeface was designed for view on all display resolutions.

Graphic Design ◁
**Nirut
Krusuansombat**

Purpose
Promotion Poster

Graphic Design ▷
**Nirut
Krusuansombat**

Purpose
**Promotion Poster
and Postcard**

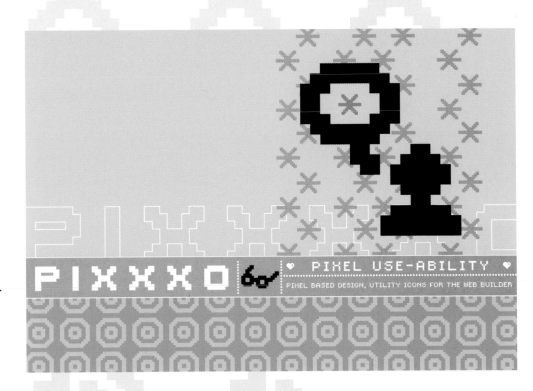

Font Name
Poet Concret

Elements
88

Style
Abstract
Artistic
Geometric

Showings Page
155

POET CONCRET

Manfred Klein *Germany*

Bauhaus-era painters and typographers Karl Gerstner and Max Bill were designer Manfred Klein's inspiration for the Poet Concret. The font consists of 88 typographical paintings in a square format. A linear grid was created to form a matrix framework. To enhance the font, Klein applied color to the characters in Adobe Illustrator adding depth and dimension. The font demonstrates how grids were converted into characters to create individual compositions.

PURCHASE ONLINE AT: **http://www.ef-fonts.de**

Graphic Design ▷
Manfred Klein
Deborah Davis

Purpose
Experimental

Graphic Design ▽
Manfred Klein

Purpose
Experimental

...clusters and
constellations
of data.
Like city lights,
receding...

Text ©1984 by Wm. Gibson, NEUROMANCER

POET CONCRET

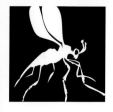

Font Name
Renfield's Lunch

Elements
74

Style
Insects

Showings Page
156

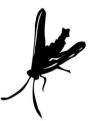

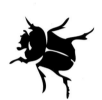

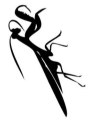

RENFIELD'S LUNCH

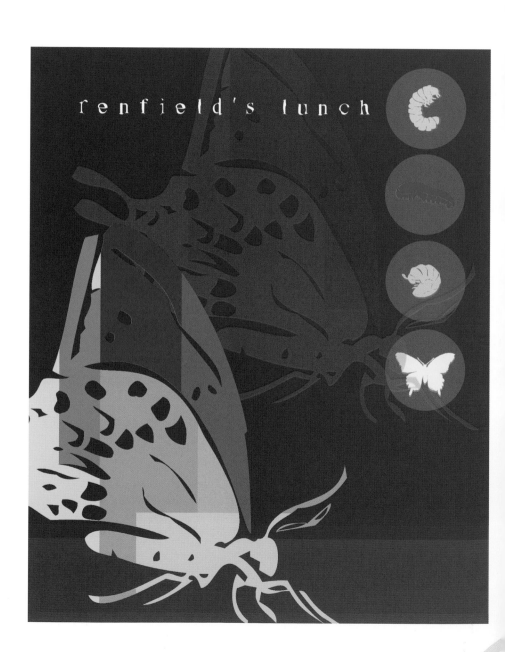

renfield's lunch

PURCHASE ONLINE AT: **http://www.garagefonts.com**

Mary-Anne King *United States*

American designer Mary-Anne King's belief in the intrinsic beauty of insects lead to the creation of the font titled, Renfield's Lunch. As a hook, she thought of her favorite bug-eater, Mr. Renfield—the rest is history. Renfield's Lunch contains a delectable assortment of 74 Insecta, Lepidoptera and Chilopoda anthropoids sure to awaken the Acrophobia, Insectophobia and Entomophobia in all of us. In 1997, this insect inspired font was awarded Third Place, Dingbat Category, in the GarageFonts/Macromedia International Font Design Contest.

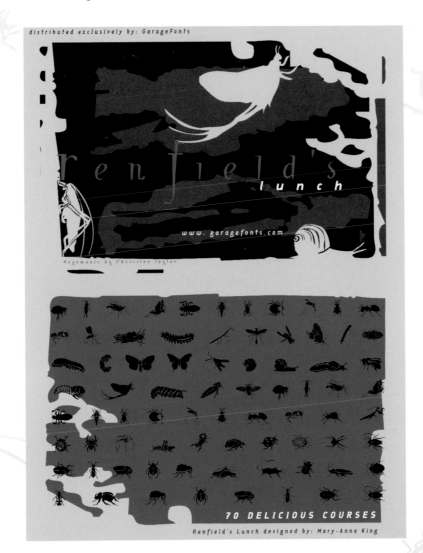

Graphic Design ◁
Felicia Anggoro

Purpose
Typeface
Promotional
Postcard

Graphic Design ▷
Betsy Kopshina
Schulz

Purpose
Typeface
Promotional
Poster

RENFIELD'S LUNCH

Font Name
RoarShock

Font Families
RoarShock One
RoarShock Two
RoarShock Three
RoarShock Four
RoarShock Five
RoarShock Six

Elements
60

Style
Abstract
Geometric
Retro
Techno

Showings Page
157

ROARSHOCK

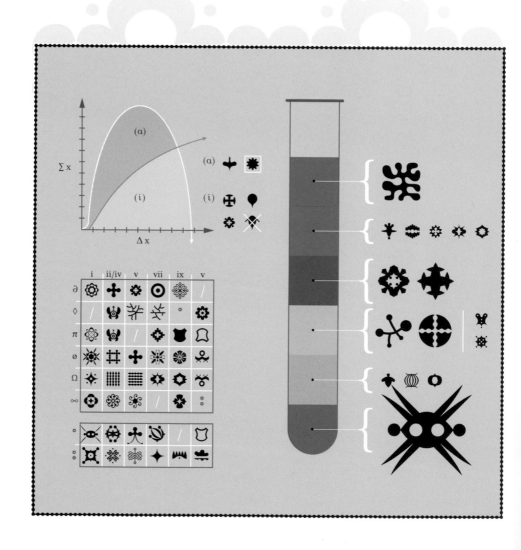

PURCHASE ONLINE AT: **http://www.fontboy.com**

Bob Aufuldish *United States*

RoarShock, designed by Bob Aufuldish, is a family of dingbat
border pattern fonts incorporating six versions, RoarShock
One through Six. Traditionally, fonts have decorative material
created specifically for it; however, RoarShock is an all-inclusive
contemporary font that relates to the fontBoy aesthetic. The
name RoarShock suggests that the apparently abstract
characters can also be interpreted.

Graphic Design ▷
Bob Aufuldish

Purpose
**Promotional
Image for
RoarShock**

Graphic Design ◁
Bob Aufuldish

Purpose
**Promotional
Image for
RoarShock**

ROARSHOCK

Font Name
Rodin Extras

Font Families
Rodin Extras

Rodin Regular

Michelangelo Extras

Michelangelo Regular

Elements
29

Style
Artistic Sculptural

Showings Page
162

RODIN EXTRAS

Denis Kegler, Richard Kegler *United States*

Rodin Extras, created by Denis and Richard Kegler from the P22 Type Foundry, includes 29 reproduction sculptural images from the noted sculptor Francois Auguste Rodin (1840–1917). The artistic set has a variety of images from his bronze sculptures including the infamous, Thinker. The great French master was strongly influenced by the immortal Italian sculptor, painter and poet Michelangelo Buonarroti (1475–1564). Created in conjunction with the Philadelphia Museum of Art, this font is a testimonial to the achievements of both renowned artists. Rodin Extras accompanies the Rodin Regular letterform font set that includes Michelangelo Extras and Michelangelo Regular.

PURCHASE ONLINE AT: **http://www.p22.com**

Graphic Design ▷
James Grieshaber

Purpose
Experimental

Graphic Design ▽
Richard Kegler

Purpose
Experimental

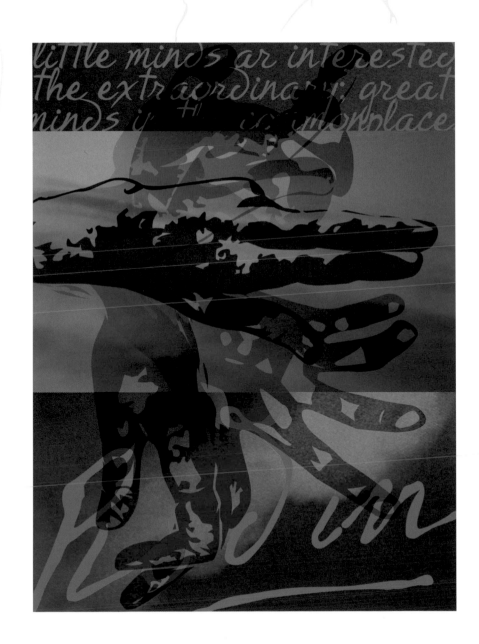

Font Name
Stars & Spirals

Elements
70

Style
**Geometric
Hand Drawn
Spirals
Stars**

Showings Page
163

STARS & SPIRALS

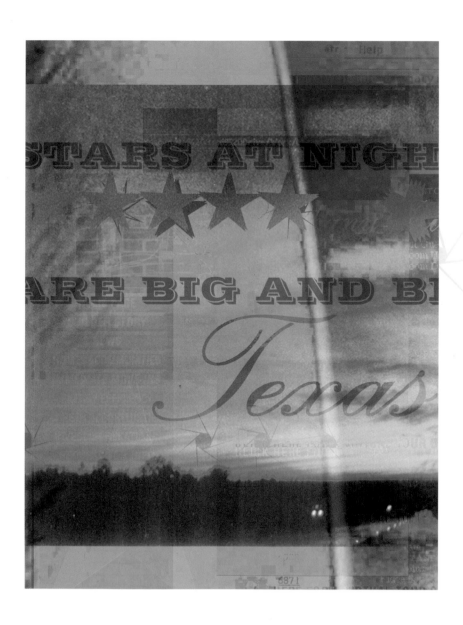

PURCHASE ONLINE AT: **http://www.ef-fonts.de**

Graphic Design ◁
Tamye Riggs

Purpose
Typeface
Promotional
Poster

Graphic Design ▽
Angus R. Shamal

Purpose
Typeface
Promotional
Postcard

Manfred Klein *Germany*

"People will always need the stars. Not only in the evening to experience how small we are when seen against the nebulae, but within the broad expanse of space," reflects Stars & Spirals' designer Manfred Klein. Klein feels we also need stars in the typographical sense in more commonplace settings, for example when a character on the keyboard is used as a footnote marker, or the star is an asterisk. Within the 70 elements in Stars & Spirals, the stars in this series have become graphic, mutating from characters to illustrations, and from asterisks to galactic spirals. Placing each one atop another in Fontographer, Klein creates supernovas and other images that can not be detected with a telescope in the night sky.

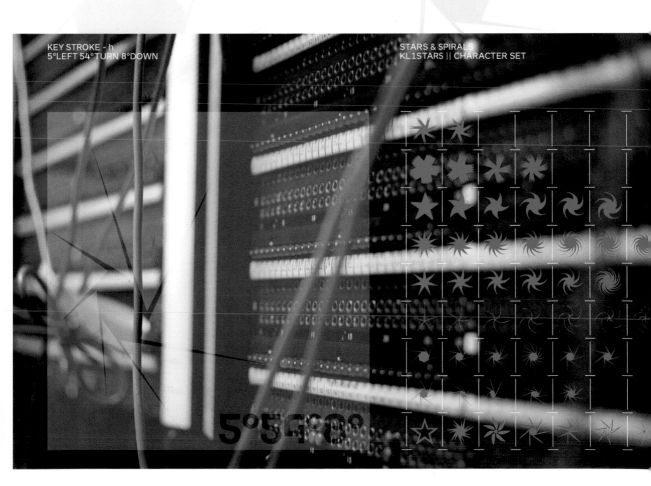

KEY STROKE - h
5°LEFT 54°TURN 8°DOWN

STARS & SPIRALS
KL1STARS || CHARACTER SET

TYPEFACES

Font Name
TypeFaces

Elements
69

Style
Artistic
Faces

Showings Page
164

Manfred Klein *Germany*

Designer Manfred Klein clever font, Typefaces, employs the literal use of the word. Klein utilizes the keyboard to illustrate the 69 faces in the set. The ingenious application is typographical metaphor at its best. Each character is composed of only letterforms and punctuation. It is a world where commas become eyes, the letter "C" is an ear or a serif "3" creates a great handlebar mustache. Klein's typographical puns fuse characters together from letters, digits and punctuation marks to form self-expressions.

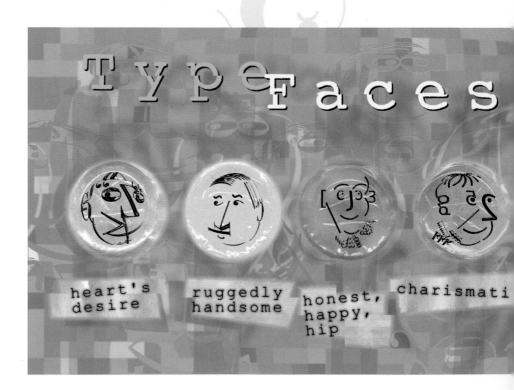

Graphic Design ▷
Kathleen Ziegler
Deborah Davis

Purpose
Typeface
Promotional
Postcard

Graphic Design ▽
Deborah Davis

Purpose
Typeface
Promotional
Postcard

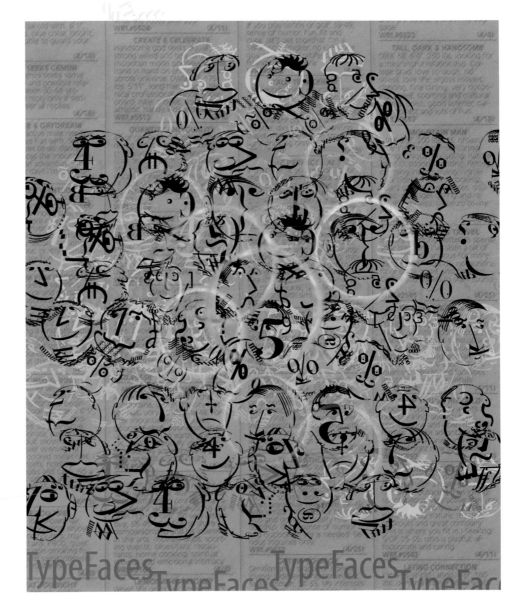

VINCENT EXTRAS

Font Name
Vincent Extras

Font Families
Vincent Extras
Vincent Regular

Elements
57

Style
Artistic
Cosmic

Showings Page
165

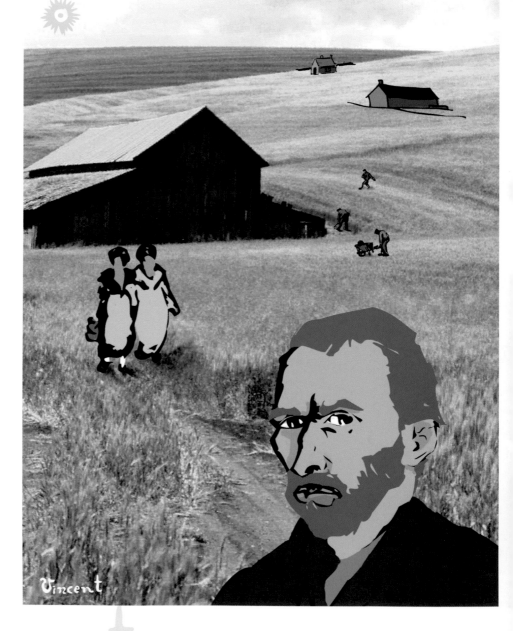

PURCHASE ONLINE AT: **http://www.p22.com**

Graphic Design ◁
Angus R. Shamal

Purpose
Typeface
Promotional
Poster

Graphic Design ▽
Tamye Riggs

Purpose
Typeface
Promotional
Postcard

Richard Kegler *United States*, **Michael Want** *United Kingdom*

This set is inspired by the impressionist painter Vincent van Gogh. Vincent Extras feature selected imagery from van Gogh's drawing and paintings. Vincent Extras accompanies the Vincent Regular letterform font that captures the essence of van Gogh's handwriting style, using the extensive correspondence with his brother Theo, as the primary reference. This lettering technique presents a bold brush-stroke appearance which bears striking similarities to the painting style of the artist. The Extras set displays iconographic images from the artist's work that include sunflowers, portraits, elements from his room and renowned signature.

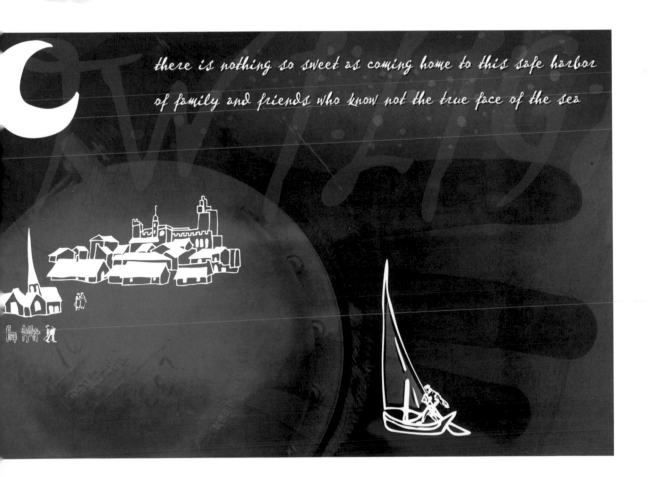

Font Name
Voxel

Elements
72

Style
Abstract
Pixel

Showings Page
166

VOXEL

Joshua Distler *United States*

Voxel, designed by Joshua Distler from Shift, shows what happens when spoken sounds are literally translated into a written form. The Voxel font is divided into two subfolders, Font and Sounds. To create its font character set of 26 word waveforms, each was first digitized and then manipulated. Next, the waveform was captured and traced to build the 36 unique letterforms. The Sounds folder contains 36 CD-quality, 16-bit, mono-sound files in a self-playing format. Double-clicking produces the actual sounds represented by each of the waveforms in the font. They can also serve as your computer system "beep".

PURCHASE ONLINE AT: **http://www.shiftype.com**

Graphic Design ▷
Joshua Distler

Purpose
Type Sample
Concepts

Graphic Design ◁
Joshua Distler

Purpose
Type Sample
Concepts

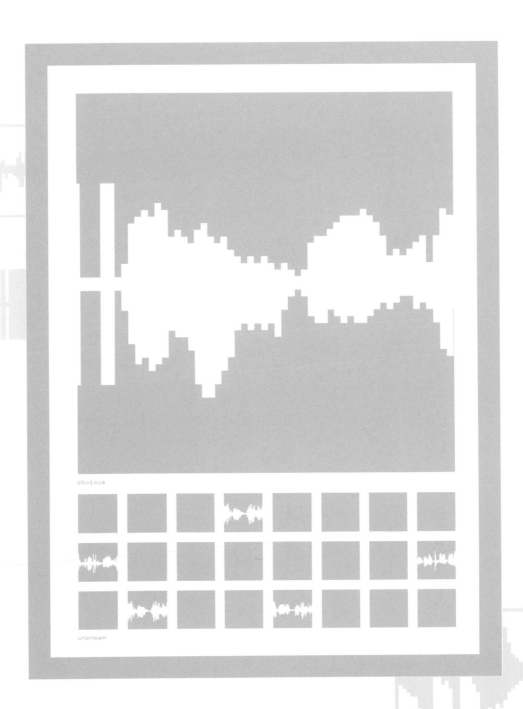

VOXEL

Font Name
Witches Brood

Elements
52

Style
Artistic
Hand Drawn
Mythological

Showings Page
167

WITCHES BROOD

Manfred Klein *Germany*

The font, Witches Brood, is a mirror of designer Manfred Klein's appreciation of painters Joan Miro and Niki de Saint Phalle. Klein illustrated 52 creatures that live in the imaginary dream space between sky and earth. Displayed are fantasy drawings spawned from Miro's microcosmos that inspired the artist to fill his font not with letters, but with the forms that reside between daytime and dreamtime. The font shows how to build an entire fantasy world utilizing nothing more than the keyboard. Klein muses, "A bit surrealistic, but ironic, too."

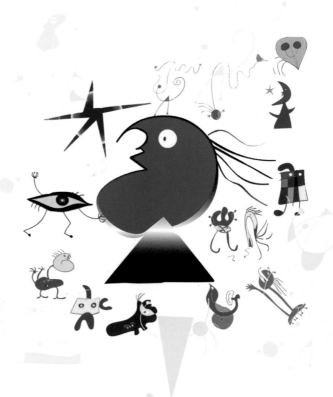

PURCHASE ONLINE AT: **http://www.ef-fonts.de**

Graphic Design ◁
Manfred Klein
Kathleen Ziegler

Purpose
Typeface
Promotion

Graphic Design ▷
Angus R. Shamal

Purpose
Typeface
Promotional
Poster

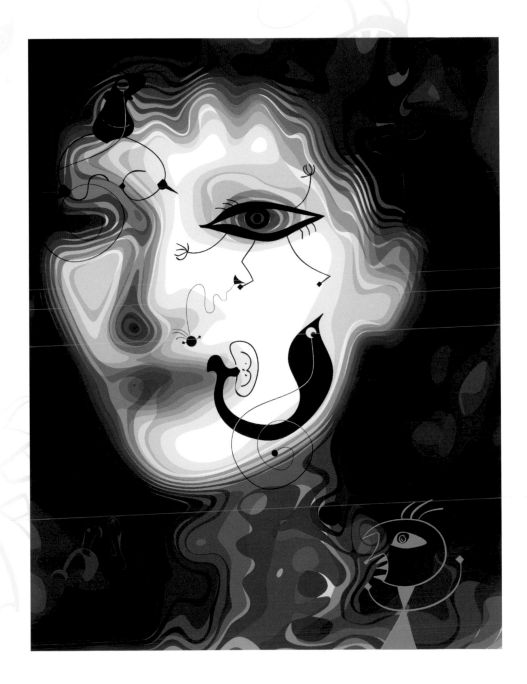

WITCHES BROOD

SHOWINGS

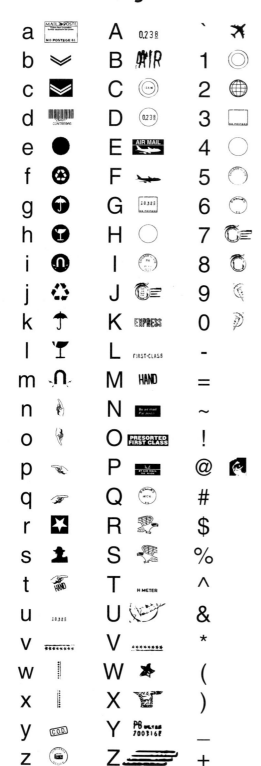

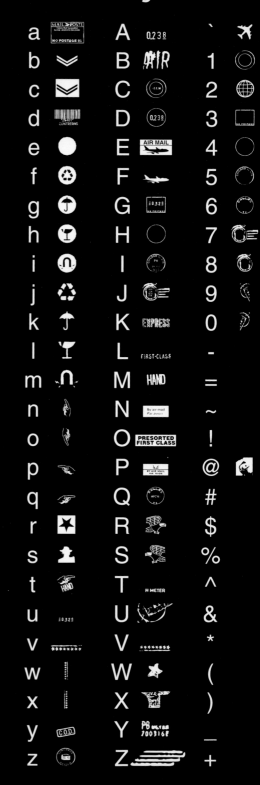

Aliens Original P.18

a		A		`		
b		B		1		
c		C		2		
d		D		3		
e		E		4		
f		F		5		
g		G		6		
h		H		7		
i		I		8		
j		J		9		
k		K		0		
l		L		-		
m		M		=		
n		N		~		
o		O		!		
p		P		@		
q		Q		#		
r		R		$		
s		S		%		
t		T		^		
u		U		&		
v		V		*		
w		W		(
x		X)		
y		Y		_		
z		Z		+		

Aliens Origina

a A
b B
c C
d D
e E
f F
g G
h H
i I
j J
k K
l L
m M
n N
o O
p P
q Q
r R
s S
t T
u U
v V
w W
x X
y Y
z Z

Aliens Head & Feeters

a	A	`
b	B	1
c	C	2
d	D	3
e	E	4
f	F	5
g	G	6
h	H	7
i	I	8
j	J	9
k	K	0
l	L	-
m	M	=
n	N	~
o	O	!
p	P	@
q	Q	#
r	R	$
s	S	%
t	T	^
u	U	&
v	V	*
w	W	(
x	X)
y	Y	_
z	Z	+

Aliens Head & Feeters

a	A	`
b	B	1
c	C	2
d	D	3
e	E	4
f	F	5
g	G	6
h	H	7
i	I	8
j	J	9
k	K	0
l	L	-
m	M	=
n	N	~
o	O	!
p	P	@
q	Q	#
r	R	$
s	S	%
t	T	^
u	U	&
v	V	*
w	W	(
x	X)
y	Y	_
z	Z	+

Astound Dings P.20

a	A	`	*
b	B	1	
c	C	2	
d	D	3	
e	E	4	
f	F	5	
g	G	6	
h	H	7	
i	I	8	
j	J	9	
k	K	0	
l	L	-	
m	M	=	
n	N	~	
o	O	!	!
p	P	@	
q	Q	#	
r	R	$	
s	S	%	
t	T	^	
u	U	&	
v	V	*	
w	W	(
x	X)	
y	Y	_	
z	Z	+	

Astound Dings P.20

a	A	`	*
b	B	1	
c	C	2	
d	D	3	
e	E	4	
f	F	5	
g	G	6	
h	H	7	
i	I	8	
j	J	9	
k	K	0	
l	L	-	
m	M	=	
n	N	~	
o	O	!	!
p	P	@	
q	Q	#	
r	R	$	
s	S	%	
t	T	^	
u	U	&	
v	V	*	
w	W	(
x	X)	
y	Y	_	
z	Z	+	

Atomica P.22

a	☢	A	△	`			
b	☢	B	△	1	⚛		
c	☢	C	△	2	⚛		
d	☢	D	△	3	⚛		
e	☉	E	△	4	⚛		
f	⚛	F	△	5	⚛		
g	◎	G	△	6	⚛		
h	⚛	H	△	7	⚛		
i	⚛	I	△	8	⚛		
j	✳	J	△	9	⚛		
k	⚛	K	△	0	⚛		
l	⚛	L	△	-			
m	⚛	M	△	=			
n	⚛	N	△	~			
o	◎	O	△	!			
p	⚛	P	△	@	⚛		
q	⚛	Q	△	#			
r	⚛	R	△	$			
s	⚛	S	△	%			
t	⚛	T	△	^			
u	⚛	U	△	&			
v	⚛	V	△	*			
w	⚛	W	△	(
x	⚛	X	△)			
y	⚛	Y	△	_			
z	⚛	Z	⚭	+			

Before the Alphabets One P.

a A `
b B 1
c C 2
d D 3
e E 4
f F 5
g G 6
h H 7
i I 8
j J 9
k K 0
l L -
m M =
n N ~
o O !
p P @
q Q #
r R $
s S %
t T ^
u U &
v V *
w W (
x X)
y Y _
z Z +

Before the Alphabets Two P.24

a A `
b B 1
c C 2
d D 3
e E 4
f F 5
g G 6
h H 7
i I 8
j J 9
k K 0
l L -
m M =
n N ~
o O !
p P @
q Q #
r R $
s S %
t T ^
u U &
v V *
w W (
x X)
y Y _
z Z +

a	A	`
b	B	1
c	C	2
d	D	3
e	E	4
f	F	5
g	G	6
h	H	7
i	I	8
j	J	9
k	K	0
l	L	-
m	M	=
n	N	~
o	O	!
p	P	@
q	Q	#
r	R	$
s	S	%
t	T	^
u	U	&
v	V	*
w	W	(
x	X)
y	Y	_
z	Z	+

Behind Bars P.26

a	A
b	B
c	C
d	D
e	E
f	F
g	G
h	H
i	I
j	J
k	K
l	L
m	M
n	N
o	O
p	P
q	Q
r	R
s	S
t	T
u	U
v	V
w	W
x	X
y	Y
z	Z

Bioprosthesis P.28

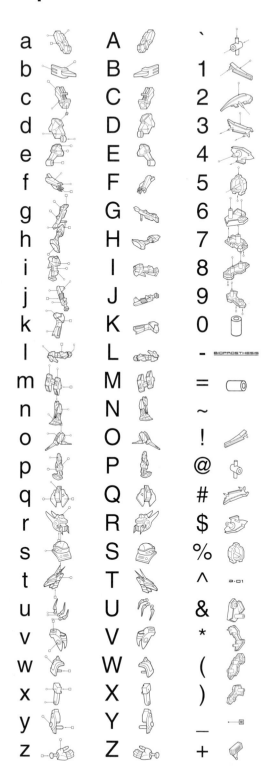

Bioprosthesis P.28

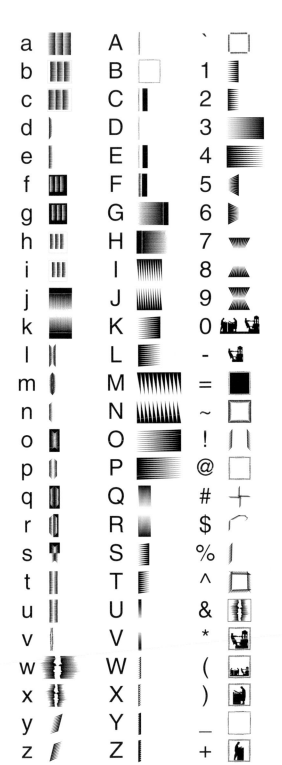

Buzzcog[A] P.32

a	◎	A	⦿	`
b	⚙	B	⚙	1
c	⚙	C	⚙	2
d	◎	D	◎	3
e	⚙	E	⚙	4
f	⚙	F	⚙	5
g	⚛	G	⚛	6
h	◉	H	◎	7
i	●	I	◎	8
j	●	J	⚙	9
k	⚛	K	⚛	0
l	⊕	L	⊕	-
m	⚙	M	⚙	=
n	⚙	N	◎	~
o	◎	O	◎	!
p	●	P	⊙	@
q	⚛	Q	⚛	#
r	⚛	R	⚛	$
s	⚙	S	⚙	%
t	◈	T	⚙	^
u	⚙	U	◎	&
v	◎	V	◎	*
w	✺	W	✺	(
x	●	X	⊙)
y	⚙	Y	⚙	_
z	⚙	Z	◎	+

`-` `—`

116

C.I.A. Department P.34

C.I.A. Depa

a		A		`		a	
b		B		1	1	b	
c		C	DRUG	2	2	c	
d		D		3	3	d	
e		E	ALOHA	4	4	e	
f		F		5	5	f	
g		G		6	6	g	
h		H		7	7	h	
i		I		8	8	i	
j		J		9	9	j	
k		K		0	0	k	
l		L		-		l	
m		M		=		m	
n		N		~		n	
o		O		!		o	
p		P		@		p	
q		Q		#	No.	q	
r		R		$		r	
s		S		%		s	
t		T		^		t	
u		U		&		u	
v		V		*		v	
w		W		(w	
x		X)		x	
y		Y		_		y	
z		Z		+		z	

| a | A | ` |
| b | B | 1 |
| c | C | 2 |
| d | D | 3 |
| e | E | 4 |
| f | F | 5 |
| g | G | 6 |
| h | H | 7 |
| i | I | 8 |
| j | J | 9 |
| k | K | 0 |
| l | L | - |
| m | M | = |
| n | N | ~ |
| o | O | ! |
| p | P CD | @ |
| q | Q DVD | # |
| r | R MD | $ |
| s | S DAT | % |
| t | T | ^ |
| u | U | & |
| v | V ON | * tb\|by\|gb |
| w | W OFF | (E-mail |
| x | X |) |
| y | Y | _ |
| z | Z | + |

Dotto One P.36

| a | A | ` |
| b | B | 1 |
| c | C | 2 |
| d | D | 3 |
| e | E | 4 |
| f | F | 5 |
| g | G | 6 |
| h | H | 7 |
| i | I | 8 |
| j | J | 9 |
| k | K | 0 |
| l | L | - |
| m | M | = |
| n | N | ~ |
| o | O | ! |
| p | P CD | @ |
| q | Q DVD | # |
| r | R MD | $ |
| s | S DAT | % |
| t | T | ^ |
| u | U | & |
| v | V ON | * tb\|by\|gb |
| w | W OFF | (E-mail |
| x | X |) |
| y | Y | _ |
| z | Z | + |

Dotto Too P.36

Ethno Paintings EF P.38

Flying Objects P.40

Flying Objects P.40

Flying OpArt P.42

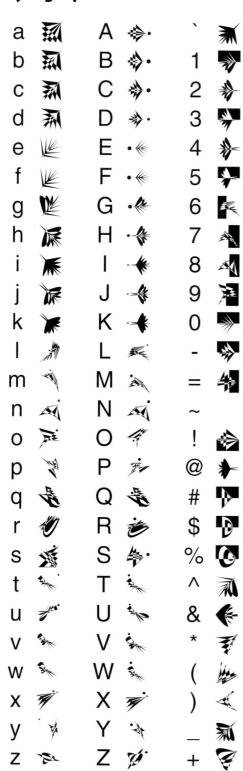

Flying OpArt P.42

FLLWTerracotta Extras P.44

a	☐	A		`	☐
b	☐	B		1	☐
c	☐	C		2	☐
d	☐	D		3	☐
e	☐	E		4	☐
f	☐	F		5	☐
g	☐	G		6	☐
h	☐	H		7	☐
i	☐	I	☐	8	☐
j	☐	J	☐	9	☐
k	☐	K	☐	0	☐
l	☐	L	☐	-	☐
m	☐	M	☐	=	☐
n	☐	N	☐	~	☐
o	☐	O	☐	!	☐
p	☐	P	☐	@	☐
q	☐	Q	☐	#	☐
r	☐	R	☐	$	☐
s	☐	S	☐	%	☐
t	☐	T	☐	^	☐
u	☐	U	☐	&	☐
v	☐	V	☐	*	☐
w	☐	W	☐	(☐
x	☐	X	☐)	☐
y	☐	Y	☐	_	☐
z	☐	Z	☐	+	☐

Fontology-E P.46

a	☐	A		`	☐
b	☐	B		1	☐
c	☐	C		2	☐
d	☐	D		3	☐
e	☐	E		4	☐
f	☐	F		5	☐
g	☐	G		6	☐
h	☐	H		7	☐
i	☐	I	☐	8	☐
j	☐	J	☐	9	☐
k	☐	K	☐	0	☐
l	☐	L	☐	-	☐
m	☐	M	☐	=	☐
n	☐	N	☐	~	☐
o	☐	O	☐	!	☐
p	☐	P	☐	@	☐
q	☐	Q	☐	#	☐
r	☐	R	☐	$	☐
s	☐	S	☐	%	☐
t	☐	T	☐	^	☐
u	☐	U	☐	&	☐
v	☐	V	☐	*	☐
w	☐	W	☐	(☐
x	☐	X	☐)	☐
y	☐	Y	☐	_	☐
z	☐	Z	☐	+	☐

a	A	`	
b	B	1	
c	C	2	
d	D	3	
e	E	4	
f	F	5	
g	G	6	
h	H	7	
i	I	8	
j	J	9	
k	K	0	
l	L	-	
m	M	=	
n	N	~	
o	O	!	
p	P	@	
q	Q	#	
r	R	$	
s	S	%	
t	T	^	
u	U	&	
v	V	*	
w	W	(
x	X)	
y	Y	_	
z	Z	+	

Gois P.

a
b
c
d
e
f
g
h
i
j
k
l
m
n
o
p
q
r
s
t
u
v
w
x
y
z

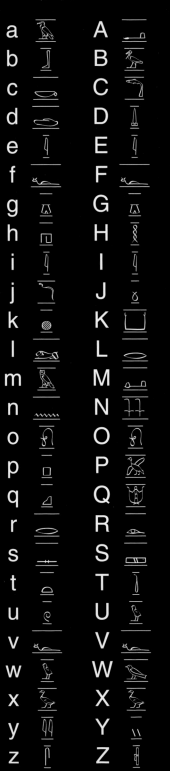

a A `
b B 1
c C 2
d D 3
e E 4
f F 5
g G 6
h H 7
i I 8
j J 9
k K 0
l L -
m M =
n N ~
o O !
p P @
q Q #
r R $
s S %
t T ^
u U &
v V *
w W (
x X)
y Y _
z Z +

Hieroglyphic Cartouche P.50

a A `
b B 1
c C 2
d D 3
e E 4
f F 5
g G 6
h H 7
i I 8
j J 9
k K 0
l L -
m M =
n N ~
o O !
p P @
q Q #
r R $
s S %
t T ^
u U &
v V *
w W (
x X)
y Y _
z Z +

a A `
b B 1
c C 2
d D 3
e E 4
f F 5
g G 6
h H 7
i I 8
j J 9
k K 0
l L -
m M =
n N ~
o O !
p P @
q Q #
r R $
s S %
t T ^
u U &
v V *
w W (
x X)
y Y _
z Z +

Hieroglyphic Decorative P.

a A `
b B 1
c C 2
d D 3
e E 4
f F 5
g G 6
h H 7
i I 8
j J 9
k K 0
l L -
m M =
n N ~
o O !
p P @
q Q #
r R $
s S %
t T ^
u U &
v V *
w W (
x X)
y Y _
z Z +

a	A	`	
b	B	1	
c	C	2	
d	D	3	
e	E	4	
f	F	5	
g	G	6	
h	H	7	
i	I	8	
j	J	9	
k	K	0	
l	L	-	
m	M	=	
n	N	~	
o	O	!	
p	P	@	
q	Q	#	
r	R	$	
s	S	%	
t	T	^	
u	U	&	
v	V	*	
w	W	(
x	X)	
y	Y	_	
z	Z	+	

Hieroglyphic Phonetic P.50

a		A		`	
b		B		1	
c		C		2	
d		D		3	
e		E		4	
f		F		5	
g		G		6	
h		H		7	
i		I		8	
j		J		9	
k		K		0	
l		L		-	
m		M		=	
n		N		~	
o		O		!	
p		P		@	
q		Q		#	
r		R		$	
s		S		%	
t		T		^	
u		U		&	
v		V		*	
w		W		(
x		X)	
y		Y		_	
z		Z		+	

HubaHuba P.52

a A `
b B 1
c C 2
d D 3
e E 4
f F 5
g G 6
h H 7
i I 8
j J 9
k K 0
l L -
m M =
n N ~
o O !
p P @
q Q #
r R $
s S %
t T ^
u U &
v V *
w W (
x X)
y Y _
z Z +

Hugi Pictural P.54

	A	`
a	A	
b	B	1
c	C	2
d	D	3
e	E	4
f	F	5
g	G	6
h	H	7
i	I	8
j	J	9
k	K	0
l	L	-
m	M	=
n	N	~
o	O	!
p	P	@
q	Q	#
r	R	$
s	S	%
t	T	^
u	U	&
v	V	*
w	W	(
x	X)
y	Y	_
z	Z	+

Il Futurismo Extras

a	A	`	
b	B	1	
c	C	2	
d	D	3	
e	E	4	
f	F	5	
g	G	6	
h	H	7	
i	I	8	
j	J	9	
k	K	0	
l	L	-	
m	M	=	
n	N	~	
o	O	!	
p	P	@	
q	Q	#	
r	R	$	
s	S	%	
t	T	^	
u	U	&	
v	V	*	
w	W	(
x	X)	
y	Y	_	
z	Z	+	

Kells Extras P.58

a	A		`
b	B	1	
c	C	2	
d	D	3	
e	E	4	
f	F	5	
g	G	6	
h	H	7	
i	I	8	
j	J	9	
k	K	0	
l	L	-	
m	M	=	
n	N	~	
o	O	!	
p	P	@	
q	Q	#	
r	R	$	
s	S	%	
t	T	^	
u	U	&	
v	V	*	
w	W	(
x	X)	IDXXI
y	Y	_	
z	Z	+	

Koch Book of Signs One P.

a	A		`
b	B	1	
c	C	2	
d	D	3	
e	E	4	
f	F	5	
g	G	6	
h	H	7	
i	I	8	
j	J	9	
k	K	0	
l	L	-	
m	M	=	
n	N	~	
o	O	!	
p	P	@	
q	Q	#	
r	R	$	
s	S	%	
t	T	^	
u	U	&	
v	V	*	
w	W	(
x	X)	IDXXI
y	Y	_	
z	Z	+	

a	A	`
b	B	1
c	C	2
d	D	3
e	E	4
f	F	5
g	G	6
h	H	7
i	I	8
j	J	9
k	K	0
l	L	-
m	M	=
n	N	~
o	O	!
p	P	@
q	Q	#
r	R	$
s	S	%
t	T	^
u	U	&
v	V	*
w	W	(
x	X)
y	Y	_
z	Z	+

Koch Book of Signs Two P.60

a	A	`
b	B	1
c	C	2
d	D	3
e	E	4
f	F	5
g	G	6
h	H	7
i	I	8
j	J	9
k	K	0
l	L	-
m	M	=
n	N	~
o	O	!
p	P	@
q	Q	#
r	R	$
s	S	%
t	T	^
u	U	&
v	V	*
w	W	(
x	X)
y	Y	_
z	Z	+

a	☉	A	♂	`	
b	☽	B	♃	1	△
c	♃	C	L	2	▽
d	♂	D	✳	3	△
e	☿	E	□	4	▽
f	♄	F	△	5	○
g	♀	G	⊕	6	⊖
h	♁	H	☌	7	☉
i	☌	I	☍	8	⊕
j	♆	J	℞	9	℮
k	♅	K	☋	0	≈
l	♇	L	☊	-	
m	☌	M	♄	=	
n	✳	N	♄	~	
o	≋	O	♃	!	☋
p	♓	P	☉	@	☊
q	♈	Q	☉	#	♏
r	♉	R	♂	$	⛎
s	♊	S	♀	%	☿
t	♋	T	☿	^	♀
u	♌	U	✝	&	□
v	♍	V	✚	*	▩
w	♎	W	✚	(♃
x	♏	X	✝)	♌
y	♐	Y	⌐	_	
z	♑	Z	✚	+	

Koch Book of Signs Three P.60

a	☉	A	♂	`	
b	☽	B	♃	1	△
c	♃	C	L	2	▽
d	♂	D	✳	3	△
e	☿	E	□	4	▽
f	♄	F	△	5	○
g	♀	G	⊕	6	⊖
h	♁	H	☌	7	☉
i	☌	I	☍	8	⊕
j	♆	J	℞	9	℮
k	♅	K	☋	0	≈
l	♇	L	☊	-	
m	☌	M	♄	=	
n	✳	N	♄	~	
o	≋	O	♃	!	☋
p	♓	P	☉	@	☊
q	♈	Q	☉	#	♏
r	♉	R	♂	$	⛎
s	♊	S	♀	%	☿
t	♋	T	☿	^	♀
u	♌	U	✝	&	□
v	♍	V	✚	*	▩
w	♎	W	✚	(♃
x	♏	X	✝)	♌
y	♐	Y	⌐	_	
z	♑	Z	✚	+	

Koch Book of Signs Four P.60

a	A	`
b	B	1
c	C	2
d	D	3
e	E	4
f	F	5
g	G	6
h	H	7
i	I	8
j	J	9
k	K	0
l	L	-
m	M	=
n	N	~
o	O	!
p	P	@
q	Q	#
r	R	$
s	S	%
t	T	^
u	U	&
v	V	*
w	W	(
x	X)
y	Y	_
z	Z	+

Koch Book of Signs Four P.60

a	A	`
b	B	1
c	C	2
d	D	3
e	E	4
f	F	5
g	G	6
h	H	7
i	I	8
j	J	9
k	K	0
l	L	-
m	M	=
n	N	~
o	O	!
p	P	@
q	Q	#
r	R	$
s	S	%
t	T	^
u	U	&
v	V	*
w	W	(
x	X)
y	Y	_
z	Z	+

a	A	`
b	B	1
c	C	2
d	D	3
e	E	4
f	F	5
g	G	6
h	H	7
i	I	8
j	J	9
k	K	0
l	L	-
m	M	=
n	N	~
o	O	!
p	P	@
q	Q	#
r	R	$
s	S	%
t	T	^
u	U	&
v	V	*
w	W	(
x	X)
y	Y	_
z	Z	+

Koch Book of Signs Five

a A `
b B 1
c C 2
d D 3
e E 4
f F 5
g G 6
h H 7
i I 8
j J 9
k K 0
l L -
m M =
n N ~
o O !
p P @
q Q #
r R $
s S %
t T ^
u U &
v V *
w W (
x X)
y Y _
z Z +

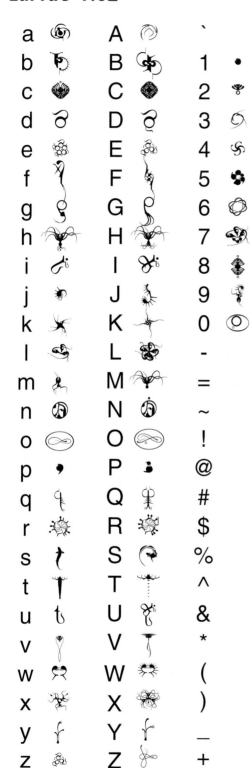

Larvae P.62

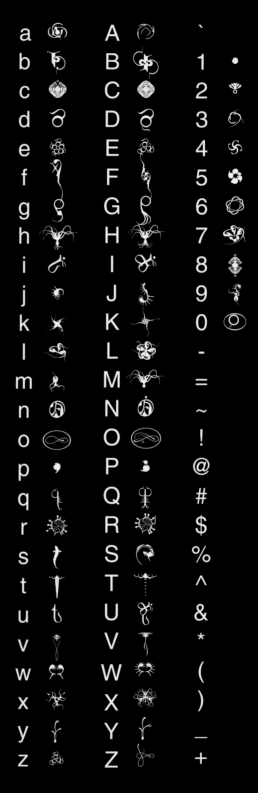

Lithium P.64

a	A	`
b	B	1
c WRITE PROTECT	C	2
d	D	3
e	E Trash	4
f	F	5
g ✖	G ✖	6
h 380	H 380	7
i	I	8
j	J	9
k	K WAIT NOW	0
l MON WALT	L	-
m	M	=
n WAIT NOW	N WAIT NOW	~
o WAIT NOW	O	!
p	P	@
q Trash	Q	#
r ONLY & 10?	R	$
s WRITE PROTECT	S WRITE PROTECT	%
t ONLY & 10?	T ONLY & 10?	^
u WRITE PROTECT	U WRITE PROTECT	&
v	V	*
w	W	(
x Trash	X)
y	Y MON WALT	_
z	Z	+

Media Icons P.66

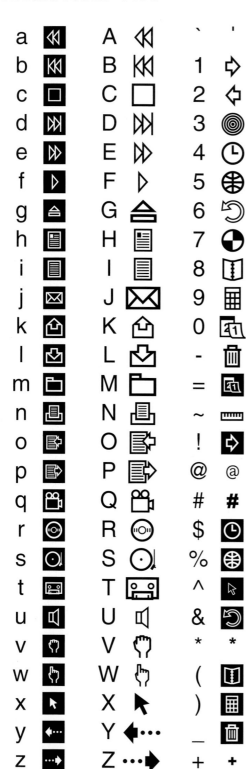

Media Icons P.66

Michelangelo Extras P.68

lowercase	uppercase	symbol
a	A	`
b	B	1
c	C	2
d	D	3
e	E	4
f	F	5
g	G	6
h	H	7
i	I	8
j	J	9
k	K	0
l	L	-
m	M	=
n	N	~
o	O	!
p	P	@
q	Q	#
r	R	$
s	S	%
t	T	^
u	U	&
v	V	*
w	W	(
x	X)
y	Y	_
z	Z	+

Michelangelo Extras P

a A `
b B 1
c C 2
d D 3
e E 4
f F 5
g G 6
h H 7
i I 8
j J 9
k K 0
l L -
m M =
n N ~
o O !
p P @
q Q #
r R $
s S %
t T ^
u U &
v V *
w W (
x X)
y Y _
z Z +

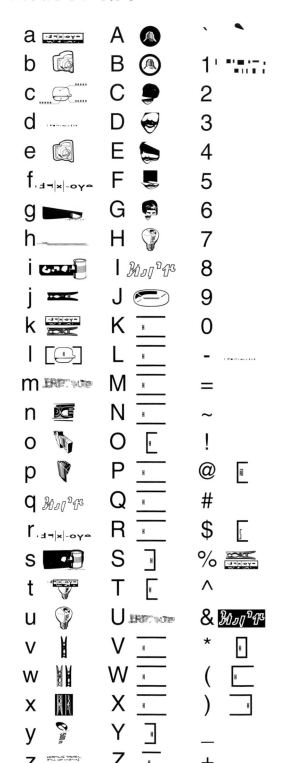

Mode 01 P.70

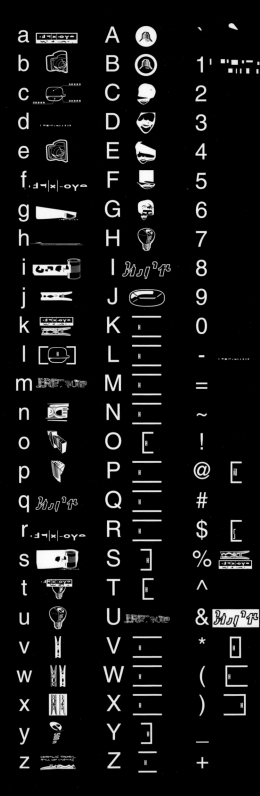

a		A		`
b		B		1
c		C		2
d		D		3
e		E		4
f		F		5
g		G		6
h		H		7
i		I		8
j		J		9
k		K		0
l		L		-
m		M		=
n		N		~
o		O		!
p		P		@
q		Q		#
r		R		$
s		S		%
t		T		^
u		U		&
v		V		*
w		W		(
x		X)
y		Y		_
z		Z		+

Monsoon P.72

a A
b B
c C
d D
e E
f F
g G
h H
i I
j J
k K
l L
m M
n N
o O
p P
q Q
r R
s S
t T
u U
v V
w W
x X
y Y
z Z

Muscles P.74

a		A		`	
b		B		1	
c		C		2	
d		D		3	
e		E		4	
f		F		5	
g		G		6	
h		H		7	
i		I		8	
j		J		9	
k		K		0	
l		L		-	
m		M		=	
n		N		~	
o		O		!	
p		P		@	
q		Q		#	
r		R		$	
s		S		%	
t		T		^	
u		U		&	
v		V		*	
w		W		(
x		X)	
y		Y		_	
z		Z		+	

Muscles P.74

a A `
b B 1
c C 2
d D 3
e E 4
f F 5
g G 6
h H 7
i I 8
j J 9
k K 0
l L -
m M =
n N ~
o O !
p P @
q Q #
r R $
s S %
t T ^
u U &
v V *
w W (
x X)
y Y _
z Z +

Oak Simblz P.76

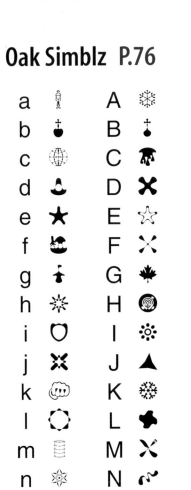

Oak Simblz P.76

Panspermia Pos P.78

a	A	`	a	A	`
b	B	1	b	B	1
c	C	2	c	C	2
d	D	3	d	D	3
e	E	4	e	E	4
f	F	5	f	F	5
g	G	6	g	G	6
h	H	7	h	H	7
i	I	8	i	I	8
j	J	9	j	J	9
k	K	0	k	K	0
l	L	-	l	L	-
m	M	=	m	M	=
n	N	~	n	N	~
o	O	!	o	O	!
p	P	@	p	P	@
q	Q	#	q	Q	#
r	R	$	r	R	$
s	S	%	s	S	%
t	T	^	t	T	^
u	U	&	u	U	&
v	V	*	v	V	*
w	W	(w	W	(
x	X)	x	X)
y	Y	_	y	Y	_
z	Z	+	z	Z	+

Panspermia Pos P.78

Panspermia Neg P.78

Panspermia Neg P.78

a	A	`
b	B	1
c	C	2
d	D	3
e	E	4
f	F	5
g	G	6
h	H	7
i	I	8
j	J	9
k	K	0
l	L	-
m	M	=
n	N	~
o	O	!
p	P	@
q	Q	#
r	R	$
s	S	%
t	T	^
u	U	&
v	V	*
w	W	(
x	X)
y	Y	_
z	Z	+

Panspermia Out P.78

a	A	`
b	B	1
c	C	2
d	D	3
e	E	4
f	F	5
g	G	6
h	H	7
i	I	8
j	J	9
k	K	0
l	L	-
m	M	=
n	N	~
o	O	!
p	P	@
q	Q	#
r	R	$
s	S	%
t	T	^
u	U	&
v	V	*
w	W	(
x	X)
y	Y	_
z	Z	+

Petroglyphs Australian P.80

a		A		`	
b		B		1	
c		C		2	
d		D		3	
e		E		4	
f		F		5	
g		G		6	
h		H		7	
i		I		8	
j		J		9	
k		K		0	
l		L		-	
m		M		=	
n		N		~	
o		O		!	
p		P		@	
q		Q		#	
r		R		$	
s		S		%	
t		T		^	
u		U		&	
v		V		*	
w		W		(
x		X)	
y		Y		_	
z		Z		+	

Petroglyphs Australian P.80

a		A		`	
b		B		1	
c		C		2	
d		D		3	
e		E		4	
f		F		5	
g		G		6	
h		H		7	
i		I		8	
j		J		9	
k		K		0	
l		L		-	
m		M		=	
n		N		~	
o		O		!	
p		P		@	
q		Q		#	
r		R		$	
s		S		%	
t		T		^	
u		U		&	
v		V		*	
w		W		(
x		X)	
y		Y		_	
z		Z		+	

Petroglyphs European P.80

a		A		`	
b		B		1	
c		C		2	
d		D		3	
e		E		4	
f		F		5	
g		G		6	
h		H		7	
i		I		8	
j		J		9	
k		K		0	
l		L		-	
m		M		=	
n		N		~	
o		O		!	
p		P		@	
q		Q		#	
r		R		$	
s		S		%	
t		T		^	
u		U		&	
v		V		*	
w		W		(
x		X)	
y		Y		_	
z		Z		+	

a	A	`	
b	B	1	
c	C	2	
d	D	3	
e	E	4	
f	F	5	
g	G	6	
h	H	7	
i	I	8	
j	J	9	
k	K	0	
l	L	-	
m	M	=	
n	N	~	
o	O	!	
p	P	@	
q	Q	#	
r	R	$	
s	S	%	
t	T	^	
u	U	&	
v	V	*	
w	W	(
x	X)	
y	Y	_	
z	Z	+	

Phantomekanix P.82

a	A	`		a	A	`	
b	B	1		b	B	1	
c	C	2		c	C	2	
d	D	3		d	D	3	
e	E	4		e	E	4	
f	F	5		f	F	5	
g	G	6		g	G	6	
h	H	7		h	H	7	
i	I	8		i	I	8	
j	J	9		j	J	9	
k	K	0		k	K	0	
l	L	-		l	L	-	
m	M	=		m	M	=	
n	N	~		n	N	~	
o	O	!		o	O	!	
p	P	@		p	P	@	
q	Q	#		q	Q	#	
r	R	$		r	R	$	
s	S	%		s	S	%	
t	T	^		t	T	^	
u	U	&		u	U	&	
v	V	*		v	V	*	
w	W	(w	W	(
x	X)		x	X)	
y	Y	_		y	Y	_	
z	Z	+		z	Z	+	

Pixxo P.84

a	☎	A		`		
b		B		1		
c		C	◉	2		
d		D		3		
e		E		4		
f		F		5		
g		G		6		
h		H		7		
i		I		8		
j		J		9		
k		K		0		
l		L	⏻	-		
m	‖	M		=		
n	»	N		~		
o	«	O	✂	!		
p		P		@		
q		Q	☠	#		
r	◀	R		$		
s	▶	S		%		
t		T		^		
u		U		&		
v		V		*		
w		W		(
x		X)		
y	◆	Y		_		
z	♥	Z		+		

Poet Concret P.86

a	A	`	
b	B	1	
c	C	2	
d	D	3	
e	E	4	
f	F	5	
g	G	6	
h	H	7	
i	I	8	
j	J	9	
k	K	0	
l	L	-	
m	M	=	
n	N	~	
o	O	!	
p	P	@	
q	Q	#	
r	R	$	
s	S	%	
t	T	^	
u	U	&	
v	V	*	
w	W	(
x	X)	
y	Y	_	
z	Z	+	

Poet Concret P.86

a	A	`	
b	B	1	
c	C	2	
d	D	3	
e	E	4	
f	F	5	
g	G	6	
h	H	7	
i	I	8	
j	J	9	
k	K	0	
l	L	-	
m	M	=	
n	N	~	
o	O	!	
p	P	@	
q	Q	#	
r	R	$	
s	S	%	
t	T	^	
u	U	&	
v	V	*	
w	W	(
x	X)	
y	Y	_	
z	Z	+	

RoarShock One P.90

a		A		`		
b		B		1		
c		C		2		
d		D		3		
e		E		4		
f		F		5		
g		G		6		
h		H		7		
i		I		8		
j		J		9		
k		K		0		
l		L		-		
m		M		=		
n		N		~		
o		O		!		
p		P		@		
q		Q		#		
r		R		$		
s		S		%		
t		T		^		
u		U		&		
v		V		*		
w		W		(
x		X)		
y		Y		_		
z		Z		+		

RoarShock One

a	A	`
b	B	1
c	C	2
d	D	3
e	E	4
f	F	5
g	G	6
h	H	7
i	I	8
j	J	9
k	K	0
l	L	-
m	M	=
n	N	~
o	O	!
p	P	@
q	Q	#
r	R	$
s	S	%
t	T	^
u	U	&
v	V	*
w	W	(
x	X)
y	Y	_
z	Z	+

RoarShock Three P.90

lower	Upper	symbol
a	A	`
b	B	1
c	C	2
d	D	3
e	E	4
f	F	5
g	G	6
h	H	7
i	I	8
j	J	9
k	K	0
l	L	-
m	M	=
n	N	~
o	O	!
p	P	@
q	Q	#
r	R	$
s	S	%
t	T	^
u	U	&
v	V	*
w	W	(
x	X)
y	Y	_
z	Z	+

RoarShock Three

lower	Upper
a	A
b	B
c	C
d	D
e	E
f	F
g	G
h	H
i	I
j	J
k	K
l	L
m	M
n	N
o	O
p	P
q	Q
r	R
s	S
t	T
u	U
v	V
w	W
x	X
y	Y
z	Z

a	A	Rodin	`
b	B		1
c	C		2
d	D		3
e	E		4
f	F		5
g	G		6
h	H		7
i	I		8
j	J		9
k	K		0
l	L		-
m	M		=
n	N		~
o	O		!
p	P		@
q	Q		#
r	R		$
s	S		%
t	T		^
u	U		&
v	V		*
w	W		(
x	X)
y	Y		_
z	Z		+

Rodin P.92

a	A	Rodin	`
b	B		1
c	C		2
d	D		3
e	E		4
f	F		5
g	G		6
h	H		7
i	I		8
j	J		9
k	K		0
l	L		-
m	M		=
n	N		~
o	O		!
p	P		@
q	Q		#
r	R		$
s	S		%
t	T		^
u	U		&
v	V		*
w	W		(
x	X)
y	Y		_
z	Z		+

Stars & Spirals P.94

a		A			`	
b		B			1	
c		C			2	
d		D			3	
e		E			4	
f		F			5	
g		G			6	
h		H			7	
i		I			8	
j		J			9	
k		K			0	
l		L			-	
m		M			=	
n		N			~	
o		O			!	
p		P			@	
q		Q			#	
r		R			$	
s		S			%	
t		T			^	
u		U			&	
v		V			*	
w		W			(
x		X)	
y		Y			_	
z		Z			+	

Stars & Spirals

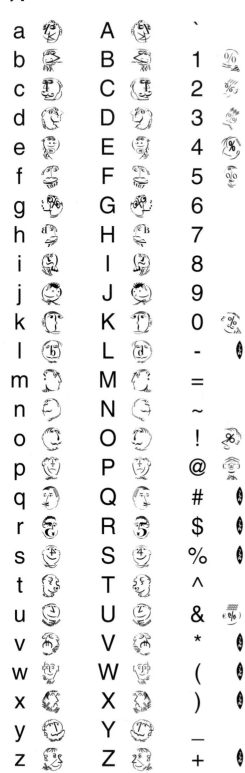

TypeFaces P.96

a	A	`
b	B	1
c	C	2
d	D	3
e	E	4
f	F	5
g	G	6
h	H	7
i	I	8
j	J	9
k	K	0
l	L	-
m	M	=
n	N	~
o	O	!
p	P	@
q	Q	#
r	R	$
s	S	%
t	T	^
u	U	&
v	V	*
w	W	(
x	X)
y	Y	_
z	Z	+

Vincent Extras P.98

Voxel P.100

a	A	`
b	B	1
c	C	2
d	D	3
e	E	4
f	F	5
g	G	6
h	H	7
i	I	8
j	J	9
k	K	0
l	L	-
m	M	=
n	N	~
o	O	!
p	P	@
q	Q	#
r	R	$
s	S	%
t	T	^
u	U	&
v	V	*
w	W	(
x	X)
y	Y	_
z	Z	+

a		A			`
b		B			1
c		C			2
d		D			3
e		E			4
f		F			5
g		G			6
h		H			7
i		I			8
j		J			9
k		K			0
l		L			-
m		M			=
n		N			~
o		O			!
p		P			@
q		Q			#
r		R			$
s		S			%
t		T			^
u		U			&
v		V			*
w		W			(
x		X)
y		Y			_
z		Z			+

Witches Brood P.102

Fonts By Alphabet

FONTS BY ALPHABET

Fonts By Style

Fonts By Foundry

Index

+ISM
London, UK
Tokyo, Japan

Contact: Matius Gerardo Grieck,
Tsuyoshi Nakazako
Email: a90037tm@plusism.com
Website: http://www.plusism.com

Behaviour Group
28/4 Soi 28 Banpruckchachart, Ramkamhang Rd.
Sapansung, Bangkok BKK10240 Thailand

Contact: Anuthin Wongsunkakon,
Nirut Krusuansombat
Telephone: 662.373.8848, 661.441.5567
Fax: 662.373.8833
Email: type@behaviourgroup.com
Website: http://www.behaviourgroup.com

The Elsner+Flake Digital Library
Friedensallee 44
22765 Hamburg Germany

Contact: Veronika Elsner, Günther Flake GbR
Telephone: 0.40.39.80.35.80
Fax: 0.40.39.80.35.70
Email: Elsner+Flake&t-online.de
Website: http://www.ef-fonts.de

fontBoy
Aufuldish & Warinner
183 the Alameda
San Anselmo, CA 94960 USA

Contact: Bob Aufuldish
Telephone: 415.721.7921
Fax: 415.721.7965
Email: bob@fontboy.com
Website: http://www.fontboy.com

FSI FontShop International
Bergmannstr. 102
D-10961 Berlin Germany

Contact: Petra Weitz
Telephone: +49.30.693.70.22
Fax: +49.30.692.84.43
Email: info@fontfont.com
Website: http://www.fontfont.de

GarageFonts
14605 Sturtevant Road
Silver Spring, MD 20905 USA

Contact: Ralph Smith, Owner or
Tamye Riggs, Creative Director
Telephone: 800.681.9375 or 301.879.6955
Fax: 301.879.0606
Email: info@garagefonts.com
Website: http://www.garagefonts.com

Manfred Klein
Text/Art
Am Sandberg 35
Frankfurt D-60599 Germany

Contact: Manfred Klein
Telephone: +49.69.96860169
Fax: +49.69.96860170
Email: m.w.klein@t-online.de
Website: http://www.manfredklein.de

LunchBox Studios
PO Box 2442
Venice CA 90294 USA

Contact: Adam Roe
Telephone: 310.306.1164
Email: info@lunchboxstudios.com
Websites: http://www.lunchboxstudios.com
http://www.reelhouse.com

MyFonts.com, Inc.
215 First Street
Cambridge MA 02142 USA

Email: info@myfonts.com
Website: http://www.myfonts.com

Nekton Design
23502 171st Avenue S.E.
Monroe, WA 98272 USA

Contact: Don Barnett
Fax: 425.402.9747
Email: don@donbarnett.com
Website: http://www.donbarnett.com

P22 Type Foundry
PO Box 770
Buffalo, NY 14213 USA

Contact: Richard Kegler
Telephone: 716.885.4490
Fax: 716.885.4482
Email: p22@p22.com0
WebSite: http://www.p22.com

Fabrizio Schiavi
Via Vignola
31 I-29100 Piacenza Italy

Contact: Fabrizio Schiavi
Telephone: 0523.758934
Fax: 0523.758934
Email: info@fsd.it
Website: http://www.fsd.it

Shift
P.O. Box 4
Burlingame CA 94011-0004 USA

Contact: Joshua Distler
Telephone: 650.737.1004
Fax: 650.343.3498
Email: sales@shiftype.com
Website: http://www.shiftype.com

[T-26] Type Foundry
1110 N. Milwaukee Avenue
Chicago, IL 60622 USA

Contact: Sun Segura
Telephone: 773.862.1201
Fax: 773.862.1214
Email: info@t26.com
Website: http://www.t26.com

Type[A] Digital Foundry
Suite 406, 3 Smail Street
Ultimo, NSW, 2007 Australia

Contact: Lewis Tsalis
Telephone: +61.2.9211.4500
Fax: +61.2.9281.9767
Email: Lewis@TypeA.com.au
Website: http://www.TypeA.com.au